Volume 8

Sun Tracks
An American Indian Literary Series

HOPI PHOTOGRAPHERS/HOPI IMAGES

SERIES EDITOR
Larry Evers

EDITORIAL COMMITTEE
Vine Deloria, Jr.
N. Scott Momaday
Emory Sekaquaptewa
Leslie Marmon Silko
Ofelia Zepeda

HOPI PHOTOGRAPHERS

HOPI IMAGES

Compiled by Victor Masayesva, Jr. and Erin Younger

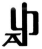

SUN TRACKS & UNIVERSITY OF ARIZONA PRESS

TUCSON, ARIZONA

This book was published in conjunction with a touring exhibition of Hopi photography, 7 *Views of Hopi*, organized by Northlight Gallery, Arizona State University.

The exhibit was funded in part by a grant from the Arizona Commission on the Arts. Additional funding was provided by the Salt River Project, Mountain Bell, Gallery Ten, and Nathaniel Owings.

Royalties from *Hopi Photographers/Hopi Images* will be assigned to a special fund at Hotevilla Bacavi Community School to support Hopi photographers.

Sun Tracks is an American Indian literary series sponsored by the American Indian Studies Program and the Department of English, University of Arizona, Tucson, Arizona. All correspondence concerning text should be sent to: *Sun Tracks*, Department of English, Modern Languages Building #67, University of Arizona, Tucson, Arizona 85721. All orders should be sent to: University of Arizona Press, 250 E. Valencia Rd., Tucson, Arizona 85706. Volumes 1–5 of *Sun Tracks* are out of print. They are available on microfiche from Clearwater Publishing Company, Inc., 1995 Broadway, New York, NY, 10023.

Library of Congress Cataloging in Publication Data
Main entry under title:

Hopi photographers/Hopi images.

 (Sun tracks; v. 8)
 "Published in conjunction with a touring exhibition of Hopi photography, 7 views of Hopi, organized by Northlight Gallery, Arizona State University"—T. p. verso.
 Bibliography: p.
 1. Hopi Indians—Pictorial works—Exhibitions.
2. Photographers—Arizona—Exhibitions. I. Masayesva, Victor. II. Younger, Erin. III. Northlight Gallery.

IV. Title. V. Series: Sun tracks; 8.
PS501.S85 vol. 8 810′.8s [779′.997′000497] 83-1301
[E99.H7]
ISBN 0-8165-0809-7
ISBN 0-8165-0804-6 (pbk.)

FOREWORD

I T COULD BE ARGUED that the single commodity most highly valued in our culture is fresh experience and that nowhere is that commodity valued more than in the world of contemporary art. As the youngest and most technological visual art form, photography is especially vulnerable to the pursuit of the "new." New ways of making photographs are constantly appearing: new instruments, new materials, new ideas. The results are praised, again and again, because they show us something that we have never seen before.

When Erin Younger approached Northlight Gallery with a proposal for an exhibition of the work of Hopi photographers, she met instant acceptance. We viewed her proposal as *new*. Our enthusiasm was, of course, also founded partly in curiosity. It is a commonly held belief that Hopi Indians are private, even reclusive, people, reluctant to be photographed. What, we all wondered, would their pictures of themselves be like?

The kinds of images that finally arrived from the Hopi photographers were not unusual: snapshots, portraits, landscapes, and visual poems. But what none of us had anticipated was the spirit in which the photographs were made and presented. The Hopi photographers clearly did not accept the pursuit of the "new" as a platform for the making of art. Whether or not a picture is "new" appears to be of no consequence whatever. The photographers seem concerned, rather, that the picture be "true": to themselves, to their subjects, to their beliefs, and to their culture.

The photographs collected in this book illuminate the astonishing spirit of those who made them. The spirit astonishes because, while Hopi culture exists in the midst of Western place and time, it miraculously persists in being itself. This persistence is not an accident: the Hopi People have willed it. We are grateful that the seven Hopi photographers whose work is represented in this book are willing to share that persistent spirit. We are all richer for it.

WILLIAM JENKINS
Director
Northlight Gallery
Tempe, Arizona

KWIKWILYAQA

Hopi Photography

Hopi Photography

WE HOPIS often find ourselves the subjects of tourist cameras. The reason is simple. As Southwest Indians we are on display, always: on napkins, on sugar and salt packets, on Fred Harvey tours and brochures, sometimes in rare library collections, but most often on postcards. As tourist attractions we remain as available as the inimitable prong-horned jack-rabbit, the rare jack-a-lope. And yet it is a fact that, although we are inundated by collectors of Indian images, we somehow keep our essential selves away from the camera.

I would risk generalizing. Hopis are very private, often secretive people who understand the value of silence and unobtrusiveness. Even if you are a Hopi photographing a Hopi, you will not confront the silences. The subjects would not expect you to, knowing that you are Hopi. And if you are a Hopi, you would not be in the confrontational situation in the first place. As a Hopi, you cannot violate the silences, just as you would not intrude on ceremony.

As Hopi photographers we are in a delicate place. Influenced by non-Hopi photographers, we are not immune to their success and their professional accomplishments. We cannot ignore the fact that certain invasions of personal spaces are effective and often very powerful statements; we cannot help but desire to duplicate their results. It is a fact that every Hopi photographer would like to photograph Snake, Flute, Antelope, Lakon dancers, plus various ceremonial events, and of course the Katcinam. And yet, when we arrive at the place and time when we do carry out those desires, when we have a disregard for everyone, everything, we will have arrived at the dangerous time prophesied by the old people. Refraining from photographing certain subjects has become a kind of worship.

As Hopi photographers we are indeed in a dangerous time. The camera which is available to us is a weapon that will violate the silences and secrets so essential to our group survival. A missionary may find our group secrets

harmful and destructive, which they may well be, to the individual. That is the essential distinction. We as Hopis, as Hopi clans, have guarded our tribal and clan secrets, perfecting our idea of what is good for sustaining group harmony, often at the expense of the individual. When the camera itself becomes a missionary, it becomes a weapon. When it is used as an individual foray into group values, it can destroy what the group has arrived at as being good.

As Hopi photographers we are in a delicate place and a dangerous time. We must look to our culture for guidance, listen to our cultural conscience, and take our cue from our comprehensive tradition which has sustained our forebears over centuries. I believe we would not be far from the mark if we were to take photography as ceremony, as ritual, something that sustains, enriches, and adds to our spiritual well-being.

Everything that is serious and important must have that lapsed moment when someone farts (an ancient Hopi saying as of this writing). Therefore, something as serious and important as photography must have the human accessory of buffoonery, and so it does, flourishing in Hopi stories. There are stories of jostling and jockeying in the plaza during the snake dances in the era of view cameras and glass plates. There are stories of blue-haired old ladies wanting authentic subject Hopis, but when presented with bared bodies clothed only in simple loincloths these same people demanded Sioux regalia and left with images of Hopis as Sioux. Despite such occurrences the Hopi indulgence for having a good time at the expense of the photographer makes photography as endurable now as it did in those times.

This impression of photographers and their physical behavior was forcefully brought to my attention one day when I was photographing an older man. He called me a *Kwikwilyaqa*. At the time I laughed thinking how appropriately this described me and what I was doing with a view camera. He was comparing me with a katcina, a spiritual being, one of that category of katcinas who involve themselves with buffoonery, burlesque, and social commentary. He looks like this (see Fig. 1): He often wears a white man's suit complete with shoes, a staff in one hand and a rattle in the other. He has a black mask with cylindrical, protruding eyes, and a mouth banded with black and white.

At the time, what made me laugh was the knowledge of what I must look like to him, under my focusing cloth, bent over my view camera. The cloth must have looked like the blanket of juniper bark which *Kwikwilyaqa* wears over his head. Later came the sober realization that he might have meant *Kwikwilyaqa* in the perspective of what this being does: he duplicates. When he comes into the plaza, this *Kwikwilyaqa* shadows anyone he can find, attaching himself to that person. He mimics every action and motion of

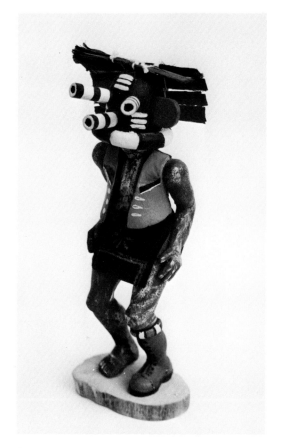

Figure 1. *Kwikwilyaqa.*
Collection of James T. Bialac, Phoenix

the harried person he selects. In this way the *Kwikwilyaqa* rapidly becomes a nuisance.

Alerted but not surprised at the acute observation on the old man's part, I thought to confirm my deductions at the risk of further denigrating myself. Unfortunately flatulent self-importance has prevented further inquiries. I console myself that I was seeing creative Hopi satire at work.

But no airs on my part will make photographers less buffoons. This aggravating, obnoxious, funny, and profoundly claustrophobic Katcina creates and contains both the photographer and the tourist. Consolation lies in his raison d'être: the *Kwikwilyaqa* is living commentary on what photographers are and what photography is; implicating us in turn, revealing what people do to people.

VICTOR MASAYESVA, JR.
Hotevilla, Arizona

CHANGING IMAGES

A Century of Photography
on the Hopi Reservation

A Century of Photography on the Hopi Reservation (1880–1980)

THE HOPI INDIANS of northeastern Arizona have been sought out by amateur and professional photographers for more than a century. While the majority of these pictures have been taken by non-Indian photographers, Hopis have also been taking pictures of themselves since the early 1940s. The cumulative record of these images is vast and covers an extensive array of subject matter. It also documents changing Hopi attitudes towards photography.

Initially, Hopis had little control over who took their picture or how they were portrayed. Government officials, missionaries, anthropologists, and tourists were among the many visitors who traveled to the Hopi mesas during the late nineteenth century. In their zeal to document Hopi life, these early photographers created a visual legacy that would define the range of Hopi photography for many years to come. By the early decades of the twentieth century, however, Hopis began to restrict access to photographers. By 1915, the photography of ceremonials had been banned. In the decades that followed, photographs continued to be taken but their content and stylistic range underwent several changes.

The first section of this essay explores the work of nineteenth-century photographers on the Hopi reservation. It identifies the scope and range of their work, as well as the nature of their interactions with the people they photographed. The second section reviews Hopi response to outside photographers and the impact Hopi attitudes have had on the photographic record. The final section addresses the emergence of Hopi photographers, the range of their work, and the dilemmas faced by community members photographing themselves.

The Early Photographers

Located in the high plateau country of what is now northeastern Arizona, the Hopi Indians were far enough away from other population centers to have remained relatively isolated from colonial contact, prior to the 1850s. Although they were visited by Spanish

explorers in 1540 and again in 1583, their territory never became a major outpost of New Spain as did the pueblos near the regional capital of Santa Fe. In the seventeenth century, a number of Christian missions were established in Hopi villages but they remained small and had only limited success in conversion. In 1680, a widespread Pueblo Revolt was staged to drive the Spanish out of New Spain. Five priests were killed in the Hopi villages, and their missions were never re-established. For the next 150 years, few outsiders passed through the Hopi mesas.

In 1848, the United States won the Mexican-American War and assumed political control over what became the American Southwest. To chart the newly acquired territory and find suitable transcontinental railroad routes, a number of reconnaissance surveys were launched in the early 1850s. In the course of these surveys, the Hopis were contacted by expedition representatives and with them documentary photographers.

Each survey had its own photographer whose job it was to document the expedition and provide illustrations for survey reports. The Indians encountered by the railroad surveys were in a practical sense considered as part of the environment, like rivers and gorges — features to be recorded. Not only did the Government want to know about the terrain and watercourses of its new lands, but also "what Indians future travelers might encounter." (1)

Following the Civil War, the focus of government surveys began to shift.

The railroad surveys were complete, and scientific and administrative investigators were assuming prominence. In the Southwest, interest focused on the study of desert lands, the geology of the Colorado River plateau, and the study of both prehistoric Indian ruins and living Indian communities. Between the 1870s and 1890s, numerous expeditions were sponsored to the Southwest, including several to the Hopi villages, funded by federal and private sources.

As the railroad surveys before them, the scientific expeditions of the 1870s and 1880s employed photographers to document and illustrate the work. Perhaps the most famous of these in the Southwest was John K. Hillers. In 1871, Hillers made his first trip down the Colorado River as a boatman for Major John Wesley Powell's Second Colorado River Expedition. Several months into the journey, Powell's photographers resigned, and Hillers took over their duties. Following that first journey, he returned to the Southwest many times as chief photographer for the Bureau of American Ethnology. The Hopis were among the Indian groups he photographed.

The photographs taken by Hillers and other expedition photographers were used to illustrate monographs and published reports. In the *First Annual Report of the Bureau of American Ethnology,* Powell described the purpose of his ethnological investigations:

The endeavor as far as possible [was] to produce results that would be of practical

value in the administration of Indian affairs, and for this purpose especial attention has been paid to vital statistics, to the discovery of linguistic affinities, the progress made by the Indians toward civilization, and the causes and remedies for the inevitable conflict that arises from the spread of civilization over a region previously inhabited by savages. (2)

Apart from such administrative missions, much of the early ethnological research was concerned with gathering detailed information about individual cultural groups and using it to reconstruct the prehistory of the region. It was generally felt that a culture was "commensurate with, and essentially equal to, the number of discrete elements or 'traits' that comprised it." (3) Thus, the work of such nineteenth-century field ethnologists as Jesse Walter Fewkes, Alexander Stephen, and George A. Dorsey was heavily weighted with detailed descriptions of Hopi traditions and material culture. Photographers followed this research direction and focused on a vast array of subject matter including portraiture, architecture, artifacts, styles of dress, and ceremonies. (Fig. 2.)

In addition to expedition documentaries, a genre of picturesque, commercial images began to appear in the late nineteenth century. These were quite different from the documentaries

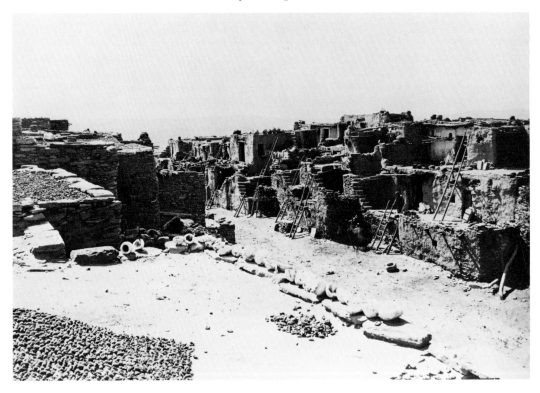

Figure 2. *Nineteenth-century documentary photographers focused on a broad range of Hopi subjects. This view of Oraibi shows peaches and squash drying in the foreground. John K. Hillers, 1879.*
Smithsonian Institution National Anthropology Archives

in content and were intended for a distinctly separate audience. That such variety in approaches to Indian subject matter arose at one time can be attributed to a number of factors.

On the one hand, the Indian Wars were over on the Plains, and the reservation system had been instituted throughout the country. The federal government was charting an assimilationist course, hoping that Indians would give up their old ways and rapidly incorporate themselves into American society. Ethnologists who went into the field during the 1890s thus hurried to record what was left of "traditional" Indian life.

At roughly the same time, the tourist industry began to flourish. The completion of the Atlantic and Pacific railroad through Arizona in 1881 greatly improved access to the Southwest, and it was not long before promoters sought to capitalize on the newly opened frontier. Tourists were lured west with tales of magnificent landscapes, friendly Indians, and colorful ceremonials.

To promote the tourist trade, a demand arose for commercial images of Indians. These images tended to be "exotic" and were often picturesque; they were used to illustrate travel brochures and to sell as souvenirs. The commercial market was lucrative. Not only did frontier studios spring up, but numerous expedition photographers added salable images to their repertoire. (4) In 1898, for example, anthropologist Walter Hough wrote a descriptive account of the Hopi Snake

dance for the Santa Fe Railroad; five years later, George A. Dorsey wrote an "ethnographic travel-log" for the same company, treating the Hopis in even greater detail. (5) Both brochures were illustrated with photographs selected to entice travelers to venture into "Indian country." Such images tended to fall into two main categories: picturesque configurations of everyday life and dramatic portrayals of ceremonial performances. (Fig. 3)

By the late 1890s, a growing number of amateur and avocational photographers converged on the Hopi mesas. Embracing the popularly held notion that Indians were a vanishing race, some had come to document the rapidly changing Hopis; others sought to reconstruct what they imagined traditional Hopi life to be.

These photographers looked largely for exotic subject matter and focused on things that appeared "different" from what they knew back home. As a result, certain images received disproportionate representation. The Snake Dance and women wearing the "Butterfly" hairdo are two notable examples in the photographic record of the Hopis. (Fig. 4)

Edward S. Curtis and Adam Clark Vroman have remained among the better-known photographers from this period. During the 1960s and 1970s their work was rediscovered and heralded as a lost national treasure. Guided by the quest of "preserving" the Indian, Curtis and Vroman were also interested in photography as art. As a result, their work was neither

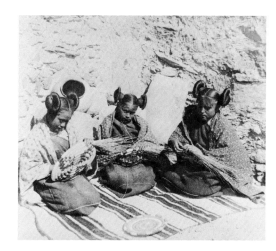

Figure 3. *Posed scenes such as this view of Hopi girls weaving baskets were sometimes taken with stereo cameras. The dual images were mounted on cards and sold for viewing in drawing rooms and parlors. Photographer unknown, published by Underwood & Underwood, 1903.*
Smithsonian Institution National Anthropology Archives

Figure 4. *Along with girls wearing the "Butterfly" hairdo, the Snake Dance was the most popular photographic subject on the Hopi reservation. Bartlett Heard, 1913.*
Heard Museum Collection, Phoenix, Arizona

Figure 5. *In this detail of "Buffalo Dance at Hano," re-touching is clearly visible on the hat and costume of the dancer at left. Edward S. Curtis, Volume XII, Plate 401.*
Special Collections, Hayden Library, Arizona State University

strictly documentary nor wholly picturesque, a problematical combination. Reassessing the work of Edward S. Curtis in 1982, Christopher Lyman wrote:

Neither Curtis's overwhelming devotion to his work nor the artistic power of what he created presents sufficient reason to accept his claim to documentation of a "vanishing race." The composite image of "the Indian" that Curtis bequeathed to us was a product of his consciousness and was designed to appeal to the consciousness of his audience. (6)

In photographing Hopis, Curtis utilized a number of techniques to capture the effects he desired. In taking pictures of the Snake Dance, for example, he used a wide-angle lens that not only froze the action of the dance but blurred the audience in the background—an audience made up largely of white tourists. Curtis also retouched his negatives, eliminating hats, suspenders, and other signs of white intrusions. (Fig. 5)

While Curtis, Vroman, and others who worked in the "art-documentary"

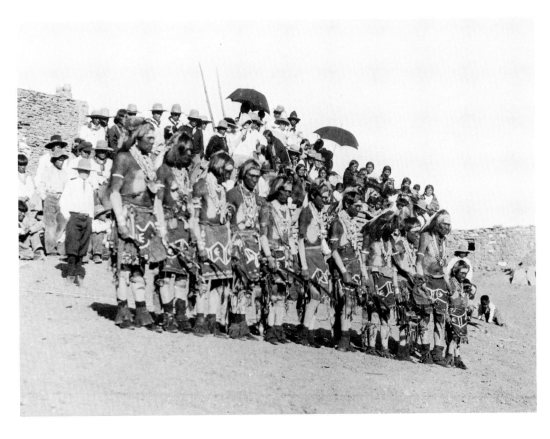

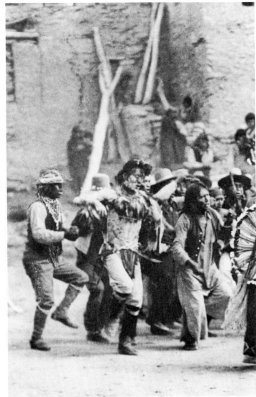

mode photographed a wide range of subjects, many of their images were portraits. These photographs are of interest in our times not only because they provide a visual record of certain individuals, but because they contain bits of information about the relationship between photographer and subject.

Several nineteenth-century photographers also wrote of their field experiences in the Hopi villages. From these accounts, it is apparent that the Hopis, even though they eventually cooperated, were initially reluctant to have their pictures taken.

Artist-photographer Frederick Monsen took pictures in the Hopi villages over a period of eighteen years, between 1889 and 1907. Recalling his 1892 visit to the Hopi village of Walpi, Monsen wrote of having gone to the home of the Governor with the following request:

I told him I wished to secure a room to live in, to arrange for Hopi servants, and to make pictures. He answered courteously that I was welcome to stay in the pueblo and might remain as long as I chose; that he would find me a house and arrange for his people to bring me wood and water, and for a woman to do my cooking, *but I must not take photographs, that he could not allow.* [emphasis added] (7)

Disappointed, but not to be deterred, Monsen went on to write that it was only with "much difficulty" that he was able to overcome the prejudices of the Governor and take pictures of the Hopis. (8)

George Wharton James, an expansive writer and prolific photographer, was in the Southwest at about the same time as Monsen. In a telling reference to a tipped-over buckboard and spilled supplies, he mentioned Hopi attitudes about photography:

. . . doubtless my cameras were smashed, and the plates I had exposed with so much care and *in spite of the opposition of the Hopis,* were in tiny pieces. [emphasis added] (9)

The difficulty of working with nineteenth-century camera equipment has been frequently noted. Not only was it necessary to carry portable darkrooms and many supplies, but the process of taking a picture was itself a significant challenge. The equipment was cumbersome and fragile, exposure times were long, and the wet-plate collodian process required that negatives be developed immediately after they were exposed. The unnatural stiffness found in early portraits was often the result of subjects being backed in to vices to hold them stationary during the long exposures. (10) Site selection was also influenced by the limitations of early camera equipment and, in particular, by the amount of available light. In the photographic record of the Hopis, there are numerous examples of subjects engaged in household activities being moved outside so photographers could better expose the negatives.

In one instance, George Wharton James described "inducing" a corn-

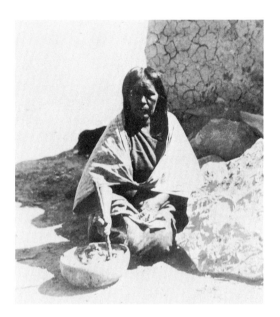

Figure 6. *It was not uncommon for photographers to request Hopi subjects to move their work outside. Judging from the stiff, inactive pose of this woman, it is likely she was complying with such a request. Attributed to Charles H. Carpenter, 1901.*
Smithsonian Institution National
Anthropology Archives

meal maker to move her things outside so he could take her picture in the sunshine. (11) (Fig. 6) In another, he wrote of assisting a fellow photographer in the documentation of making *piki* (a thinly rolled corn bread):

One of my party wished to make moving photographs of making *piki*. [The *piki* maker] cheerfully moved outside. She insisted, however, upon placing [her stone] so that her back was in the blazing sun.... It was in vain that I explained to her why she must face the sun.... In desperation, I seized the heavy stone and carried it to where I desired it to be. (12)

The intent of these photographers was clearly to document what they felt were either interesting or typical Hopi activities. By posing their subjects to the extent indicated, however, they lost much of the value of their work: a photograph of a *piki* maker out in the sun simply did not provide an accurate record of the homemaker's industry.

James's comments also reveal the growing congestion caused by photographers and other visitors to the Hopi villages. In their curiosity, tourists often thought little of interrupting daily Hopi life. Photographers frequently came to the Hopi reservation in clubs and would move through the village in groups. It was not unusual as a result to find large crowds around a single subject. In reference to the picture of the woman making cornmeal, for example, James ended his comments by writing that once he had the woman posed, "eight other kodak and camera fiends insisted upon 'shooting' the scene." (13)

In many references, mention is made of paying Hopis to pose. The precedent for payment in the field was set in the 1850s when early scientific investigators "paid for information rather than demanding services." (14) As the tourist industry began to boom, Hopis charged photographers one dollar to bring cameras on the reservation. Additional payment was often either offered or requested. That the rates paid were extremely variable is highlighted also in James's writings. In one case, each of nine photographers paid a dime to photograph one woman (15); in another, each of twenty-three women requested a new dress before allowing photographers to take their picture building a wall. (16) Fee payment was both a courtesy to and a small source of income for individual Hopis. The system, however, underscored the fact that regardless of the good intentions of the photographers, the Hopis were curiosities in their eyes.

It is obvious, however, that once initial objections were overcome, numerous photographers struck up good relations with individual Hopis. Comfortable smiles and relaxed poses characterize much of the photographic record, particularly the portraits of George Wharton James, A. C. Vroman, Frederick Monsen, and Edward S. Curtis. (Fig. 7) Although Hopis were sensitive to intrusions by photographers, they were also interested in the art of the camera. From the start, they readily accepted duplicate prints and often hung these images on the walls of their homes.

Although the majority of turn-of-the-century photographers sought to cultivate comfortable relationships with Hopi Indians, there were those among them who abused their privileges and felt compelled to photograph forbidden subjects. Such illicit photography was probably tied both to curiosity and a conviction that Hopi traditions must be recorded for posterity, whether or not the Hopi people agreed. Photographs taken inside *kivas* (underground ceremonial chambers) are the most notable examples of this abuse. Secretive field methods, however, were used in many other situations, sometimes to record "unusual" subject matter, other times to capture a "candid" effect.

In a series of articles for *Craftsman* magazine, Frederick Monsen described some of the methods he used in photographing the Hopis. His remarks not only illuminate his field techniques, but also allude to the complicated interplay between the goals of art and documentation. He wrote that it required "much diplomacy and careful arrangement" to get the kind of pictures he wanted. These pictures were "truthful" but also imbued with a certain "effect":

A photographer who uses the large camera and plates the full size of the finished picture can seldom get either the atmosphere or the freedom from consciousness that is so desirable when photographing Indians. . . . My own method is to carry three small cameras which fit . . . around my waist and are concealed under my loose coat. One turn of my hand and the camera is out and ready for use. . . . Of course, all my Indian friends know in a general way that I make many pictures of them, and some of them are occasionally asked to pose for some especially desired effect, but when they do not see the camera as I stroll around and chat with them, they have no consciousness of being on dress parade for a possible picture, and those who do notice my movements, pay but little attention to an occasional unobtrusive snapshot by someone else. (17) (Fig. 8)

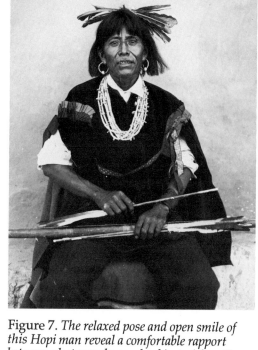

Figure 7. *The relaxed pose and open smile of this Hopi man reveal a comfortable rapport between photographer and subject. Adam C. Vroman, 1901.*
Western History Collection, Natural History Museum of Los Angeles County

Figure 8. *Where some photographers carefully posed their subjects, others desired the more candid effects that could be obtained in the public areas of the villages. This group of Hopi women and children show no awareness of Frederick Monsen who was apparently positioned on an adjacent rooftop. Frederick Monsen, 1890.*
Huntington Library, San Marino, California

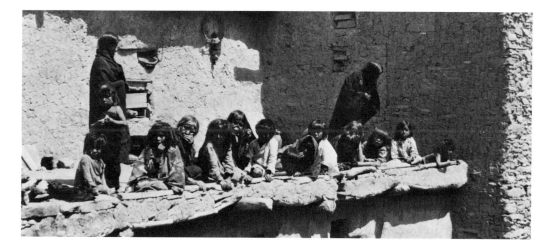

As rolled paper film gradually replaced glass plate negatives, secrecy in photography became much easier. Kodak introduced the first roll film in 1884 and, by the late 1890s, it was in general use by most photographers. Not only was picture-taking made easier for field photographers, but for hobbyists as well.

For anthropologists, missionaries, and tourists alike, the *kiva* held a tempting fascination. It was the center of Hopi ceremonial life and, like the inner sanctum of a church, was a place to worship and participate in ritual. Although access was denied to most outsiders, the lure of the *kiva* was so great that stories abound of curious travelers "bursting in" to startle Hopi priests. For those few visitors who were granted access, respectful behavior was expected and without question, photography was prohibited. Secret photographs were nonetheless taken.

In one example, George Wharton James had been invited into the *kiva* to witness the washing of snakes prior to the Snake Dance. Concluding a description of the experience he wrote:

As soon as all the snakes were washed, all the priests retired except those whose duty it was to guard the snakes. Then it was that I dared to risk taking off the cap from my lens, pointing it at the almost quiescent mass of snakes and trust to good luck for the result. (18)

The Reverend Heinrich R. Voth was another photographer of forbidden *kiva* scenes. A Mennonite missionary, Voth lived in Oraibi between 1893 and 1902. During those years he also worked for the Field Columbian Museum of Chicago as an associate of anthropologist George A. Dorsey. In his work as an ethnologist, Voth took many pictures in the Hopi villages.

Voth was a man apparently torn in his loyalties. Several times he was nearly persuaded to leave the church for full-time work at the Field Museum. Although he stayed with his mission, he wrote several volumes of detailed observations on Hopi traditions. At the same time, he worked to introduce Christianity. The unusual combination of missionary and anthropologist apparently enabled him to feel justified in intruding on the *kiva*, where he photographed and collected religious materials.

To most outsiders, religious practices were the most curious and perplexing aspects of Hopi life. It was, in fact, to observe and photograph ceremonies that most tourists traveled to the Hopi mesas. Of the many ceremonies performed annually, none was as fascinating to outsiders as the Snake Dance. A supplication for rain, the Snake Dance includes a public performance where dancers carry venomous snakes in their mouths. To nineteenth-century visitors, the Snake Dance was an incredible spectacle to behold; to the Hopis it was a sacred performance. Within a few years of the arrival of tourists in the Hopi villages, the Snake Dance had become the most heavily photographed event on the mesas.

In 1902, in response to growing disruptions caused by photographers, government agents and Hopi officials

restricted photographers at Oraibi to a confined area of the plaza. In an article for *Camera Craft* magazine, George Wharton James wrote:

Hitherto, every man had chosen his own field and moved to and fro wherever he liked—in front of his neighbor or someone else, kicking down another fellow's tripod and sticking his elbow into the next fellow's lens. (19)

Whether the behavior was quite as rambunctious as James described, there can be no doubt that photographers "got in the way"—not only of each other, but also of Hopi spectators and dancers. Pictures from the era show photographers crowding Hopis to such an extent that in some scenes, white spectators clearly outnumber Hopi dancers. (Fig. 9)

By the turn of the century, a range in the approach to photographing Hopis had been established that would persist well into the twentieth century. Extending from documentary to picturesque, the recorded images varied from accurate description to inaccurate stereotype; from sensitive portrayal to intrusive depiction. Overall, however,

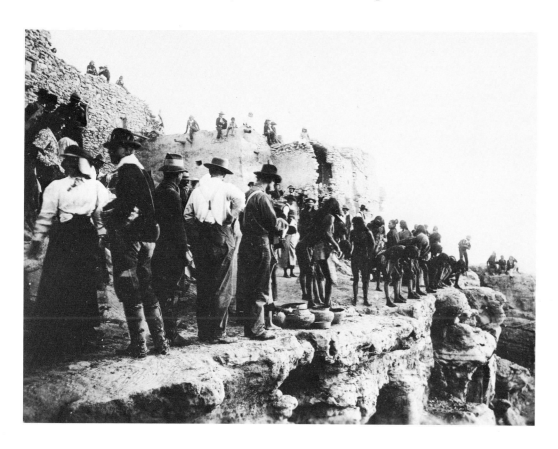

Figure 9. *In this and other photographs from the late 19th century, white spectators clearly crowd Hopi Snake dancers, shown here taking the emetic at the end of the dance. Attributed to G. W. James and F. H. Maude, 1897.*
Smithsonian Institution National Anthropology Archives

the pictures of Hopis went a long way in establishing an alternative view of the Indian. Taken when much of the public thought of Indians as "bloodthirsty savages," the Hopi photographs represented a view of picturesque and "peaceful" people. As one photo-historian has written:

The Hopi photographs often caused those whose only impression was derived from hearsay to understand all Indians from a new and sympathetic perspective. (20)

This perspective, however, was clearly the view of an outsider looking in. It would be several decades before a Hopi perspective began to emerge and several more before it became well established.

Changing Attitudes and Limited Access

Hopis responded in several ways to the growing pressures of visitors in their villages. The most pertinent responses, as far as the photographic record was concerned, consisted of increased restrictions on access to subject matter and a higher degree of secrecy. Not only were photographers confined to limited areas at the Snake Dance, but signs began to appear warning tourists to stay out of *kivas* and other private areas. (Fig. 10)

By 1915, photography of ceremonials had been banned by most Hopi villages. (21) The decision to ban photography was supported by government agents as well as Hopi leaders. To the Hopis, the restriction of photography meant a restoration of order to their

ceremonies. To the agents, it was a move to limit publicity:

It was believed that photographing ceremonies provided unwanted encouragement for the Indian to retain native customs and discouraged the assimilation of white ways. (22)

In spite of the limits on photography, the demand for pictures of Hopis remained high. To meet this demand, several trends and stylistic conventions emerged in the 1920s that reinforced and expanded the range of images taken in the late 19th century.

One of these trends was an increase in the number of pictures of Hopis taken outside the reservation setting. These images fell into several categories including fanciful commercial photographs, pictures of Hopis as craft demonstrators, and "official documentaries" promoting a progressive view of modern Hopis.

The image of the Indian as a horse-mounted warrior had become well established by the end of the Plains Indian wars and was perpetuated in popular literature, traveling road shows, and Hollywood movies. The Hopis became a part of the legend in the mid-1930s when Mr. M. W. Billingsley organized a traveling program of Hopi Snake Dancers. A local variation on Buffalo Bill's Wild West Show, Billingsley's group was the featured attraction at a Sears and Roebuck anniversary celebration held in Miami, Florida, in 1936. In one set of publicity photographs, the Hopi dancers were pictured on stage performing

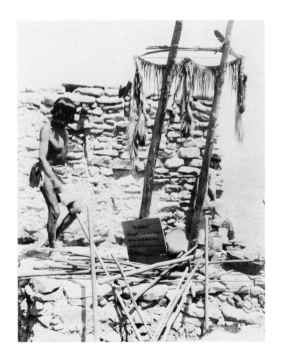

Figure 10. *By 1901, tourists had become so disruptive that cautionary signs were posted in the villages. This one reads: "To all visitors: the men of the Snake Order desire that none enter the Snake Kiva and that all refrain from making noise in the vicinity thereof." Photographer unknown, copyright October 14, 1901.* Smithsonian Institution National Anthropology Archives

in costume. In another, they were posed formally with Mrs. Billingsley, dressed up in feathered headdresses, Navajo necklaces, and with "war" paint on their faces! (Fig. 11)

Numerous other fanciful images were created during the 1920s and 1930s, many destined for postcard publication. In one, a small Hopi child was posed naked on a ladder halfway up the side of a pueblo. The caption read: "Cupid at home in Hopiland." (23) In another, published by the Fred Harvey Company in 1921, Hopi models were posed at the Grand Canyon as "Hopi Romeo and Juliet." (Fig. 12)

Such incongruous scenes perpetuated a romanticized vision of remote places few non-Indians would ever see. The content of these images was particularly ironic, since it appeared at the same time the social distance between Indians and whites was beginning to decrease. It was during the 1930s, in fact, that genuine policy reforms were beginning that would change the official relationship between Indians and the federal government. In 1934, the Indian Reorganization Act repudiated the Congressional land allotment policy, and federal concern for education,

Figure 11. *Capitalizing on the popularity of the Plains Indian stereotype, Hopi dancers were dressed in feathered war bonnets to pose with Mrs. Billingsley for the 50th anniversary celebration of Sears and Roebuck in Miami, Florida. Miami Daily News, February 2, 1936.* Arizona Collection, Hayden Library, Arizona State University

Figure 12. *Appealing to the commercial tourist market, fanciful pictures of Indians were popular during the 1920s and 1930s. "Hopi Romeo and Juliet" was taken at the Grand Canyon. The Fred Harvey Company, 1921.* Fred Harvey Collection, Heard Museum, Phoenix, Arizona

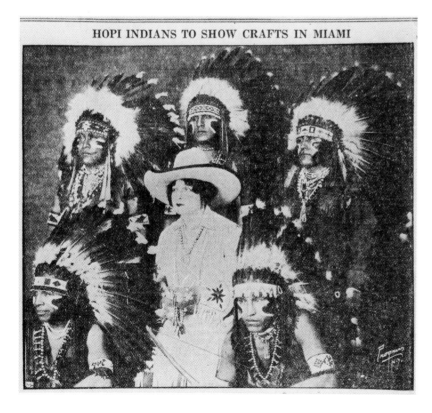

HOPI INDIANS TO SHOW CRAFTS IN MIAMI

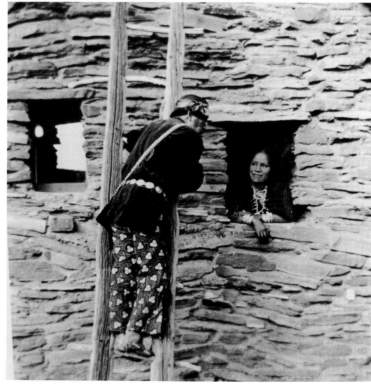

Figure 13. *As museums began in the 1930s to sponsor annual Indian arts and crafts shows, prize winners were often photographed with their work, creating a documentary record of known individuals in contrast to the largely anonymous portraits of the late 19th century.*
Museum of Northern Arizona, Flagstaff

Figure 14. *In the context of craft demonstrations in museums and galleries, tourists have been able to photograph Hopis in much the same way that their 19th century counterparts took pictures in the villages. This woman is painting pottery at the "Hopi House," Grand Canyon, Arizona. El Tovar Studio.*
Fred Harvey Collection, Heard Museum, Phoenix, Arizona

health, and economic development in Indian communities increased.

During this same period, the market for Indian arts and crafts began to grow. Exhibits were sponsored throughout the country, and annual competitions were organized, especially in the Southwest and Oklahoma, offering prize money and purchase awards. Winning artists were often photographed with their artwork. (Fig. 13) These images have become documentary records of known individuals, distinguishing them from the majority of nineteenth-century portraits that either isolated picturesque "types" or focused on the process of making cultural items.

With collectors becoming increasingly interested in individual Indian artists, museums and galleries began in the 1930s to invite Hopis and other Indians to demonstrate in "living" displays. In such settings, tourists could photograph Hopis in much the same way their nineteenth-century counterparts took pictures in the villages. Such snapshots served to document the technique of craft-production in an economic context, and became visual souvenirs of trips to museums. (Fig. 14)

The activity of outside photographers on the reservation dropped off sharply after the turn of the century. The few pictures taken fell into the

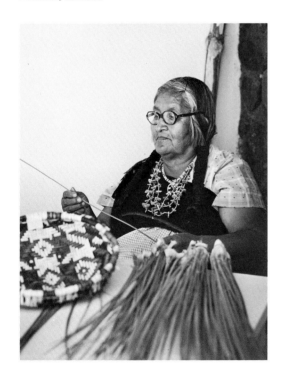

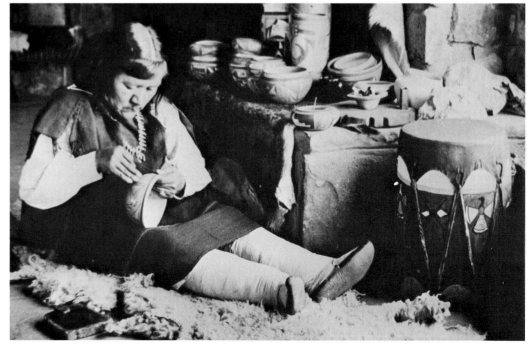

familiar categories of architecture, portraits, and documentary sequences. Notably missing were photographs of ceremonies and open plaza scenes.

Social change within the reservation community and recent growth in the Southwest have added to the categories already described, particularly since the 1940s. One new category has focused on modernization, offering glimpses of "progressive" Hopis at work. Another consists of Chamber of Commerce-type presentations. Picking up where nineteenth-century tourist brochures left off, these have made use of the old-style images, museum-style documentaries, romanticized portraits, "public relations" shots, and the full range of other possibilities.

The Indian Reorganization Act of 1934 authorized Indian tribes to estab-

lish constitutional governments. In a controversial election, where only a minority of the eligible voters cast ballots, a tribal council was established on the Hopi reservation. After the council was formed, various federal programs were undertaken, administered by the Bureau of Indian Affairs (BIA). In the context of these programs, numerous "official-documentary" photographs were taken. The majority of these presented a positive view of modern Hopis—council members in conference; students poring over open books; technicians working in modern facilities. Taken in a journalistic style, these pictures have been used to illustrate government reports, local news stories, and academic books —they have not been turned into postcards. (Fig. 15)

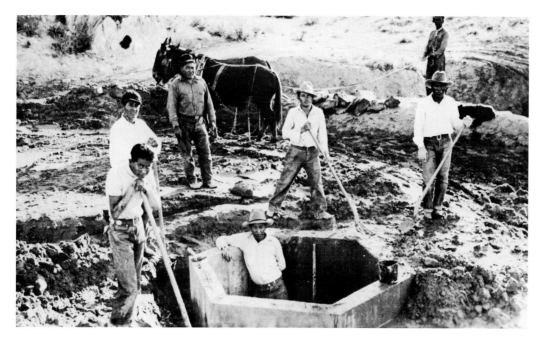

Figure 15. *Taken in a journalistic style, pictures of government-sponsored land improvement projects show "progress" in the making and present a positive view of modern Indians. This crew was completing work on the Bean Spring reservoir.*
Arizona Collection, Hayden Library, Arizona State University

Coinciding with such "progressive" images have been photographs that continue to preserve a sense of the "otherness" of the Hopi Indians. The curtailment of photography on the reservation posed obvious problems to publishers of tourist-oriented periodicals. One solution was to reproduce photographs taken prior to 1915. In this context, photographs of Nampeyo making pottery, women wearing the Butterfly hair style and men weaving sashes have become synonymous with "Hopi." The promotion of twentieth-century arts and crafts in such a manner, however, conveys at least two different impressions: One is a sense of time-depth in the arts. The other is an impression of cultural rigidity — staged scenes become stationary symbols of what are in fact evolving processes.

One of the more popular forums for the ongoing promotion of Hopis and other southwestern Indians has been *Arizona Highways* magazine. First published in 1925 by the Arizona Highway Department, by the 1970s the magazine was being sent to subscribers throughout the United States and in over one hundred foreign countries. (24) Travel to "Indian country" has been seasonally promoted in the magazine since the 1930s and because of the August Snake Dance, Hopis have frequently been mentioned in spring and summer issues.

Although *Arizona Highways* has not been alone in publicizing the Hopis, a review of its back issues reveals an encompassing array of visual solutions to the problem of restricted photography on the reservation. The handling of ceremonial subjects has been especially problematical since ceremonies have remained popular tourist attractions. The Snake Dance, in particular, has received distinctive treatment.

In July 1931, *Arizona Highways* published its first full article on the Hopi Snake Dance. Written by Mrs. Lamar Cobb, "Hopi Snake Dance is Spectacular Ceremony" included one illustration. A fairly dark reproduction, its caption read: "The white man's duplication of the Hopi rites as presented each year in Prescott in the Smoki Dances." Without photographic access to the ceremony, a photograph of non-Hopis offering their version of the performance was presented instead.

In 1932, the vacation issue of the magazine ran a photograph of "Chimopovi" (Shongopovi) on its cover. Its caption stated that "Chimopovi" was one of "8 Hopi villages where the annual Snake Dance is held." The following month, an article on "The Legend of the Hopi Snake Dance" was illustrated by a studio photograph of a Katcina doll, a "type of Eagle dancer." (Fig. 16) In these and other examples, a specific event (in this case, the Snake Dance) was advertised by a photograph of something else; in one case a village, in another a wooden doll. Such illustrations were selected for their generally "exotic" qualities with the intent of enticing readers into imagining the nature of life on the Hopi reservation.

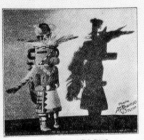

Figure 16. *To circumvent the ban on photography of ceremonials, a picture of an Eagle katcina doll was used to illustrate an article on the legend of the Hopi Snake Dance. Arrowhead Studio, 1932.*
Arizona Highways Magazine, July, 1932

The most popular way to circumvent the photography ban was to reproduce images of the Snake Dance taken prior to 1915. Tourist brochures and newspaper articles had been using the photographs of James, Vroman, Hillers, and Curtis for years. During the 1930s and 1940s, the practice was also popular with *Arizona Highways*.

The August 1933 issue was the first to reproduce a nineteenth-century photograph in the context of a modern promotion. Its caption read: "The Snake Dance of the Hopi. Pictures of this most weird of Indian religious rites were becoming scarce. No cameras had been permitted at the ceremonial since 1915." The same image and identical caption were used two years later to illustrate an article entitled "Writhing Reptiles and Dancing Red Men."

One impression conveyed by the use of nineteenth-century images was that the ceremonies never changed, that they were ancient rituals perpetuated by indomitable forces. This attitude was literally conveyed in the caption to a 1913 photograph of the Snake Dance, published in 1950: "Only the audience changes, the dances are the same." (25)

Contrary to such an impression, Hopi ceremonies incorporate spontaneous creativity just as they follow tradition. It is thus partially due to the tendency of photographs to freeze fleeting moments that Hopis have continued to resist entreaties for permission to photograph their ceremonies. Such dynamics simply cannot be adequately captured in still photography.

During the 1940s and 1950s, a number of photographers whose work has since become well known began taking pictures of Hopis: Senator Barry Goldwater, Esther Henderson, Ray Manley, and Jerry Jacka among them. Following in the footsteps of their nineteenth-century predecessors, these photographers have taken portraits of Hopis and documentary sequences of traditional activities. (Fig. 17) They have been driven not so much to record the "vanishing" Indians as to become champions of the regional

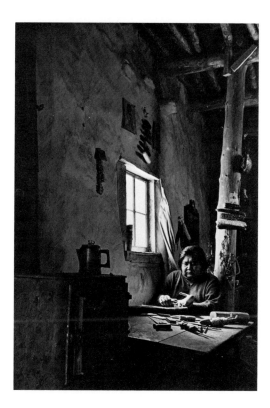

Figure 17. *In a continuation of the 19th century documentary tradition, Jerry LaCapa of Walpi was photographed carving a katcina in 1980. Jerry Jacka, 1980.*

resources of Arizona. Landscape photographers Ansel Adams and Joseph Muench have also taken pictures in the Hopi region, and these too have been reproduced in numerous publications. (Fig. 18.)

Following the Second World War, popular publications, echoing the work of prominent museums, began to focus on arts and crafts as collectibles. *Arizona Highways* published its first color-spread of Indian arts in the January, 1945, issue. As the market has continued to grow, a complementary genre of photographs has emerged, showing artists posed with their work. While similar to the documentary images of arts and crafts' show winners, these pictures tend to be more picturesque. (Fig. 19)

Another pictorial convention that had been used sparingly prior to the 1950s but blossomed with the craft market was the creative use of Hopi katcina dolls to depict Hopi religion. As the dolls made for sale became increasingly realistic, photographers could more readily create illusions, posing the carved figures dramatically so they appeared to be real.

The entire June, 1971, issue of *Arizona Highways* was devoted to ''The Living Spirits of Kachinas.'' In the editor's introduction, readers were told:

This special issue is unique because it marks the first time that we have reproduced photographs depicting the Hopi Indian Kachina dances and ceremonies without violating any of the restrictions

Figure 18. *Walpi pueblo. Ansel Adams, 1941–42.*

Figure 19. *As individual Hopi artists have become well-known, a complimentary genre of picturesque photographs has emerged. Joy Navasie is shown here surrounded by her prize-winning pottery. Ray Manley Studios, 1974.*

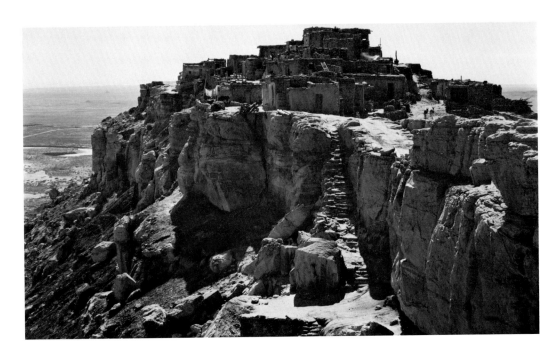

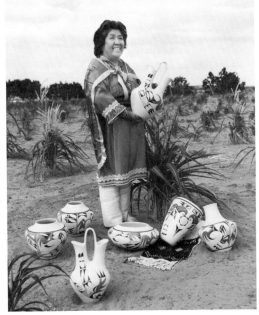

which have heretofore prohibited photographic exposure of the Hopis' colorful religious festivals, known as Kachina dances. (26)

The photographs consisted of striking groupings of dolls posed against stormy skies and panoramic vistas. (Fig. 20) The images were created to convey a mood, which they do, but the mood conveyed is an approximation at best, a misinterpretation at worst. This style of presentation remains popular and can be found in most books on katcina dolls, many general publications, and on innumerable postcards.

Since the 1960s, non-Indian photographers working with Hopis have become increasingly deferential to Hopi attitudes about photography—even when Hopi attitudes run counter to their goals as artists or photographers on assignment. Arizona photographer Jerry Jacka has stated:

...I can understand why the old people not only want to keep out the photographer, but also anyone who jeopardizes their culture. (27)

John Running is another photographer who has worked extensively with Indian subjects but whose work in the Hopi villages has been limited:

I haven't spent much time working on the Hopi reservation because the Hopis don't usually like people walking around in their villages with cameras...and I don't want to intrude on Hopi privacy. (28)

He went on to acknowledge that the photographs included in a portfolio published in 1980 were taken at the

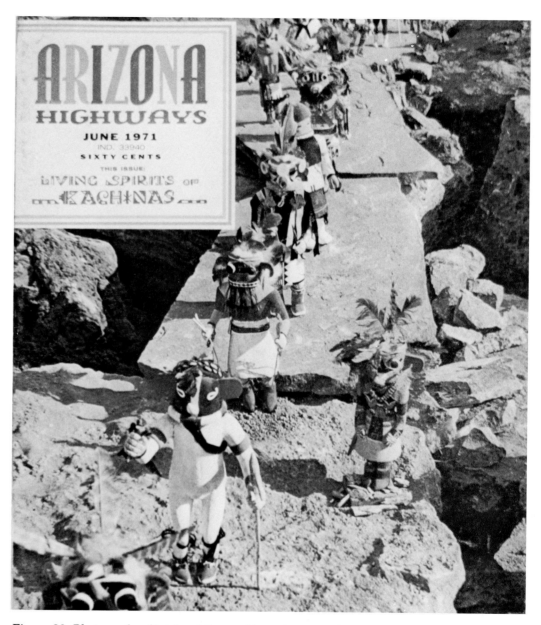

Figure 20. *Photographs of katcina dolls posed in environmental settings have become popular substitutions for photographs of katcina dances. In an effort to make the dolls appear more "real," the supporting bases of two figures in the foreground have been covered with rocks. Paul Coze, 1971.*
Arizona Highways Magazine, June, 1971

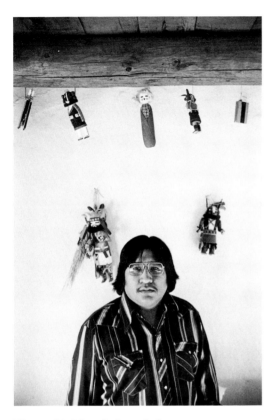

Figure 21. *Marvin Lomahaftewa. John Running, 1979.*

Hopis' request, and that he returned copies of the prints to all who posed for him. (Fig. 21)

And yet, no matter how good, complimentary, realistic or artful the images, the persistent demand for photographs of Hopis and their commercial use raise unavoidable conflicts between the Hopis who desire privacy and the photographers who make their living selling pictures of Indians. The September 1980 issue of *Arizona Highways* is an example, not only of the ongoing conflict between commercial and non-commercial motives, but of the distance between an insider's and an outsider's view of the Hopi reservation.

Dedicated to the Hopis' celebration of their successful revolt from Spanish domination in 1680, the tricentennial issue of the magazine was promoted as a collaborative effort between the Hopi people and the magazine's staff. Several Hopi photographers were asked to submit prints to the publication and the tribe assisted in setting up interviews for the writers. Of the numerous photographs submitted, however, only three were found to be compatible with the magazine's style. One was printed as a translucent throw-away cover, the other two were greatly reduced in size and reproduced as images subordinate to the text. Although one article was entitled "On Being Hopi," no Hopi writers were represented. In a compliant gesture, a note on the magazine's inside back cover stated: "To respect the privacy of the Hopi, *Arizona Highways* is suspend-ing reproduction of 35mm color slides for this month only." In that same year, however, a packet of "commemorative" Hopi images was published in postcard form, reproducing in sepia tones twelve of the color images from the tricentennial issue.

The Emergence of Hopi Photographers

Hopis became interested in photography soon after their villages were "discovered" by nineteenth-century photographers. It would be several decades, however, before Hopis began taking pictures of themselves and several more before their work extended beyond snapshot photography. When it did, it exhibited significant continuities with the photographic record; it also departed in a number of important ways. Hopi snapshots, for example, have rarely been taken in an attempt to document anything more ambitious than family or community events. As a result, they offer a varied and personal view into daily Hopi life. Hopi portraits not only reveal access to specific individuals but have been handled in a proprietary manner—they have not been offered for sale and they have not been available for commercial reproduction. Documentary images have also had the potential, sometimes realized, to reflect distinctive views of tradition and change. Creative photography has revealed a unique blending of Hopi references with contemporary artistic concerns.

To consider Hopi photography as categorically different from non-Hopi

photography obscures many similarities that are to be found both in style and the range of subject matter recorded. It also overlooks variations that occur on an individual level, regardless of the identity of the photographer. The feeling that there *are* qualitative differences, however, is frequently expressed by Hopi photographers:

I take the kinds of photographs that other people [non-Hopis] can't take. (29)

Non-Indians have never been able to correctly capture the picture of the Hopi people. There have been many attempts, sometimes by good people. But they can't find the real truth. Only Hopis can do that. (30)

Statements of this kind are both provocative and difficult to prove or disprove. Such concerns not only reflect differences between Hopi and non-Hopi views of the world, but also between the relative access to subject matter for a community member as compared to a non-member.

The community member's view can be most readily seen in the approach to subject matter—in the determination of what is important to record, and why. It can also be seen in the handling of photographs once they have been taken:

I have never sold my portraits. People have offered to buy them, but it's something the Hopi feel very strongly about. I would never sell a portrait. (31)

In the past, there was too much of a commercial interest. (32)

Hopi photographers bring an honesty and a lack of commercial intent that other photographers did not bring to Hopi. We are not out to exploit our people, as we have seen in so many postcard publications. We simply want people to see us as we see ourselves. We are photographers working with a cultural conscience. (33)

This cultural conscience may be difficult to maintain as interest in Hopi photography increases, but for now, the concept has helped to maintain the delicate balance between personal artistic goals and obligations to the Hopi community. In stylistic terms, Hopi photography spans many of the formal conventions mentioned in the earlier sections of this essay. It also includes work that is more clearly aligned with modern photography, distinguishing it from the art-documentary tradition so prevalent in the photography of Indians.

Family or snapshot photography has been little different on the Hopi reservation than in any rural community. As cameras have become less expensive and easier to operate, more Hopis have purchased them. Prior to the 1940s, most snapshots came from outside sources; from visiting photographers returning to the reservation, from students home on vacation, from relatives who had moved to the cities. By the 1940s, Hopis began taking pictures of themselves. Jean Fredericks was one of the earlier Hopi photographers. Although not the first, his career as a family photographer typifies the identity and range of Hopi snapshot photography.

Figure 22. *Formal portrait of a Fredericks family member.*

Figure 23. *Family snapshot. Jean Fredericks.*

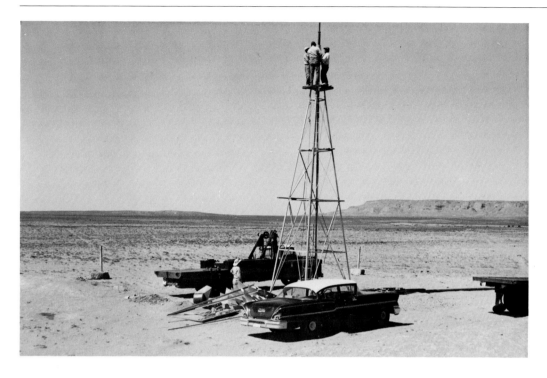

Figure 24. *Documentary photograph of the construction of a well published by the Bureau of Indian Affairs, Land and Water Operations branch. Jean Fredericks, 1959.*

Like most amateur photographers, Fredericks learned by trial and error. When he returned to the reservation after serving in World War II, he outfitted a small darkroom to develop his own prints. The majority of his photographs have been family snapshots, and he has occasionally taken studio-style portraits, usually on request. These have been for home or family use, however, and have not been sold or reproduced. (Figs. 22 and 23).

In addition to family photography, Fredericks has also taken documentary images. During the 1950s and 1960s he was a field supervisor for the BIA, working on their Land and Water Operations. He took numerous photographs documenting these projects.

When government officials became aware of his work, they paid to develop his prints. Several were used as report illustrations. (Fig. 24) These pictures were taken in a straight documentary style and fall clearly within what was earlier called the "official-documentary" mode of photography. They focus on land improvement projects and feature the involvement of Hopis in the process.

Beginning in the late 1960s, Hopi photography expanded to encompass portraiture, documentary sequences, photo-journalism, and interpretive or "art" photography. For some photographers, media involvement was prompted by political considerations. In the words of one film-maker:

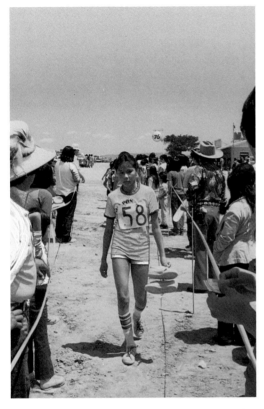

Figure 25. *Coverage of local sporting events is a regular feature of* QuaToqti, *the Hopi tribal newspaper. Merwin Kooyahoema, 1981.*

. . . the turmoil of Indian activism in the late Sixties and early Seventies played a major part in exposing Native American peoples to the role of the media and how it could be used to advantage . . . "By-for-and-about" became the criteria by which everything about Indians was to be judged. (34)

During the 1970s tribal newspapers were founded throughout the country. *Qua Toqti* and the *Hopi Tribal News* were formed on the Hopi reservation and have consistently featured coverage of local and regional news, written and photographed by Hopi journalists. (Fig. 25)

Hopi portrait photography grew from family snapshots and from the precedent set by non-Hopi photographers. In many cases, artistic and documentary goals have been similar, although the Hopi photographers' position as community members has given a somewhat different perspective to their work. In the words of Owen Seumptewa:

In the beginning, I simply wanted to offer some quality documentation of the people themselves. The early anthropologists at least provided us with some photographic documentation of what things looked like. We must be grateful for that. But we have to go further. We have to look at ourselves and create something that our children will be able to look back on. Something other than snapshots. (35) (Fig. 26)

As the quality of Seumptewa's work has become known, more Hopis have requested him to take pictures of their relatives. The majority of his portraits have been commissioned in this manner, as have portraits by other Hopi photographers. For some, the increased interest in portraiture has created temptations, for others, a split sense of responsibility:

In twenty years the reservation will be very different. There is really no way to stop the change. You simply have to live with it. As a Hopi, I have a responsibility to record it and preserve it and try to make people on the outside understand it. (36)

Efforts to make people understand it have included a willingness to publish in art and educational journals. Owen Seumptewa, for example, has not sold his portraits commercially, but has requested permission to publish the photographs at his own discretion. His photographs have appeared in various educational journals as well as *Arizona Highways* (the tricentennial issue), *Sun Tracks,* and numerous in-house publications produced by Navajo Community College.

Other Hopis have publicized their portraits even less. Victor Masayesva, for example, has only recently exhibited his portraits, even though he is an accomplished photographer. Georgia Masayesva has worked more closely with children and has focused as much on architecture and patterns as she has on people. (Fig. 27) This reticence stems largely from a reaction to the long history of outside photographers profiting from their portraits of the Hopi. Whether individual permission to reproduce an image has been granted or not, charges of exploitation and commercialism circulate each time

a new book or illustrated article on the Hopi is published. Hopi photographers have thus far sought to avoid similar charges, either by not taking portraits at all, or by maintaining control over the distribution of their images.

During the 1970s, photography and television began to be used extensively to record stories and other tribal traditions that had formerly been passed along orally. In 1976, Owen Seumptewa served as photographic consultant to the Hopi Tribe, documenting the villages, the people, and several archaeological and architectural restoration projects on the reservation.

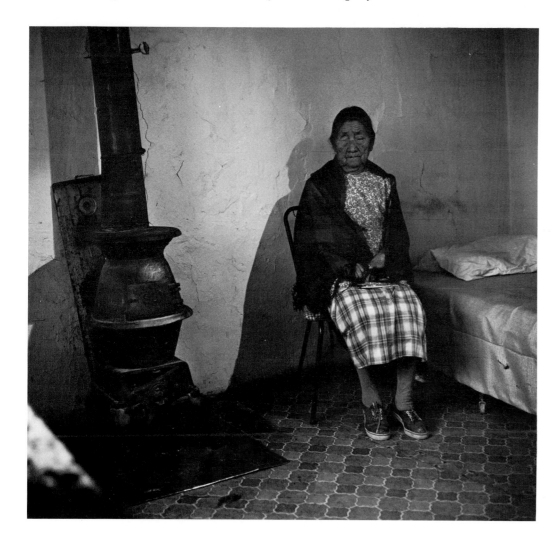

Figure 26. *Left. Owen Seumptewa has specialized in portrait photography, particularly of older Hopis. Owen Seumptewa, 1978.*

Figure 27. *Above. Portraiture and architecture are often combined in Georgia Masayesva's photography. Georgia Masayesva, 1980.*

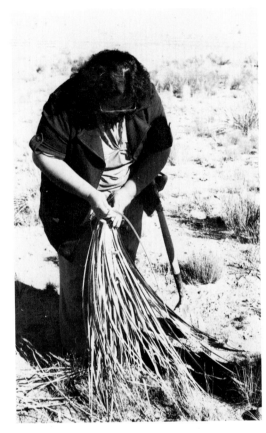

Figure 28. *Documentary photograph of a woman gathering basketry materials. Freddie Honhongva, 1981.*

Figure 29. *Documentary photograph of a weaver spinning wool. Victor Masayesva, Jr., 1981.*

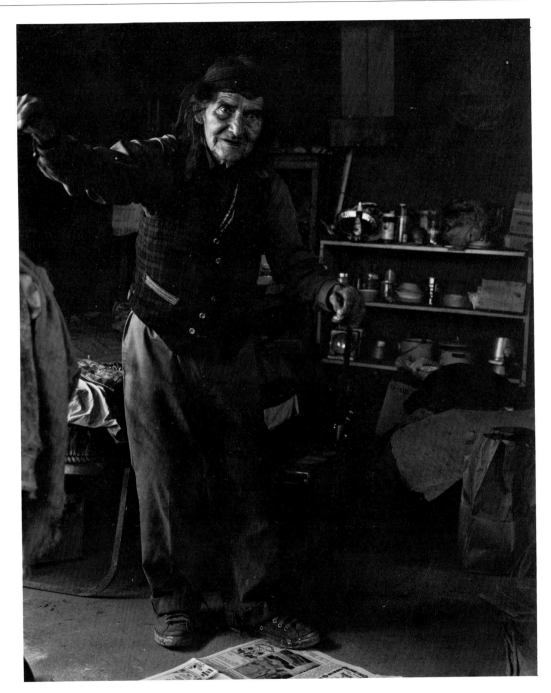

In 1980, the Hotevilla-Bacavi Community School on Third Mesa received a grant from the Ethnic Heritage Program of the Department of Education to produce a series of documentary tapes. Victor Masayesva directed the project and by the end of 1981 had produced sixteen edited tapes, recorded in Hopi. Numerous other Hopi photographers have created documentary sequences, often focusing on the process of preparation, such as the gathering of basketry materials, or spinning of wool. (Figs. 28 and 29) Such images are not only filling in the documentary record, but are preserving an insider's view of tradition and change.

Little has been said in the preceding pages about photography as an art form. Yet, from the beginning, changing perceptions of art have played a major role in defining the photographic image of the Hopi and the manner in which that image is to be understood. To capture the essence of Hopi has motivated photographers from the 1880s to the present and has been a creative challenge for Hopi and non-Hopi photographers alike. Stylistic conventions have come and gone, but it has been the power of individual vision that has distinguished the best work, elevating Curtis and Vroman above their contemporaries, Running and Jacka above their peers.

In like manner has art distinguished the work of Hopi photographers. Owen Seumptewa's portraits are studies in personal dignity and cultural perseverance. Georgia Masayesva's doorways and shadowy children are mysterious forms, beckoning the viewer inside down darkened hallways. Victor Masayesva's images are visual poems. As metaphors they center on prophecy and survival, story-telling and Hopi beliefs, "the way life and death slip by one another." (Fig. 30)

In Hopi photography as in Hopi life, references and obligations overlap. Images lead into stories, stories into the past, the past into prophecies, and prophecies back to the present. The Hopi photographers represented in this book have indeed maintained the delicate balance between their individual goals as photographers and their obligations to the Hopi community. In the face of mounting pressures and conflicting motivations, to photograph themselves, however, is to come close to "confronting the silences," to unleashing the potential to "destroy what the group has arrived at as being good." It remains to be seen from where future photographers will take their cues, but for now, the balance has been kept, and we, the viewers, are offered an insightful view into contemporary Hopi life.

ERIN YOUNGER
Phoenix, Arizona

Figure 30. *"The Kikmongwi's Rain Song"* is part of a series of photographs and poems centering on the theme of survival. *Victor Masayesva, Jr., 1979.*

PHOTOGRAPHING OURSELVES

Images From Hopi Photographers

Jean Fredericks

I have been taking pictures, mostly of friends and family, since the 1940s. Privately, many Hopis approve of photography and want pictures of their families and celebrations, just like anyone else. Publicly, many feel they have to adopt a political position against photography, to be careful of what they say or what others will say about them. This is to protect their privacy. Personally, I am glad people are interested in my photographs and that my hobby will help people better understand the Hopis.

JEAN FREDERICKS was born in Old Oraibi in 1906. He attended grade school on the Hopi reservation and later went to the Sherman Indian Boarding School in Riverside, California. After graduation from the Sherman school, he worked both on and off the reservation as a mechanic. He served in the U.S. Army and in the 1960s was elected as Chairman of the Hopi Tribe.

Fredericks bought his first camera in 1941 and became one of the first Hopis to take photographs on the reservation. After his service in the Army, he outfitted a darkroom at his house where he did his own developing. The majority of his photographs have been family snapshots. He has also taken formal portraits and documentary images.

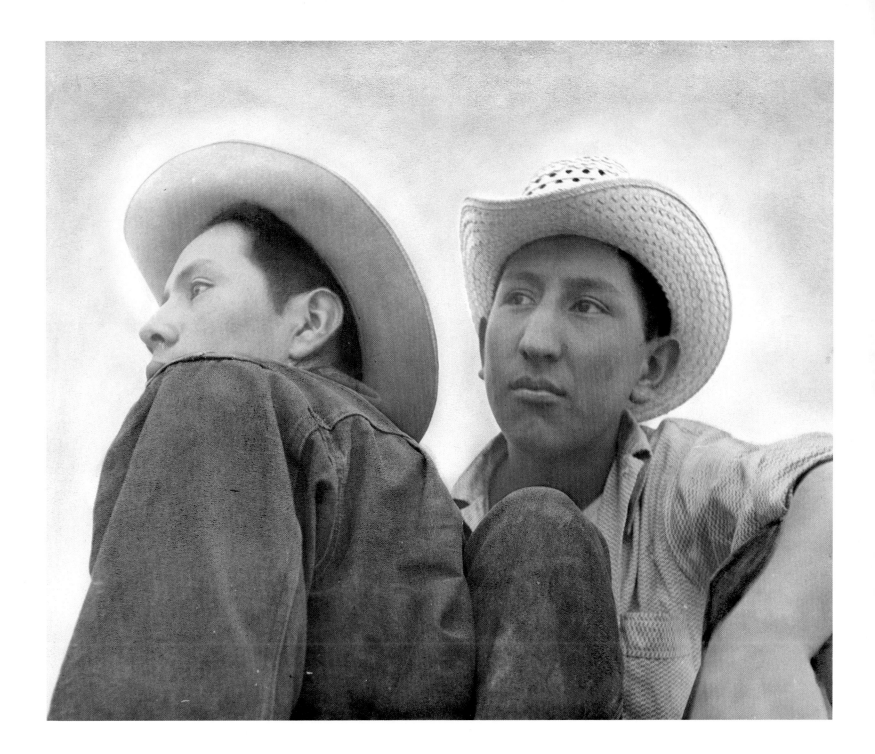

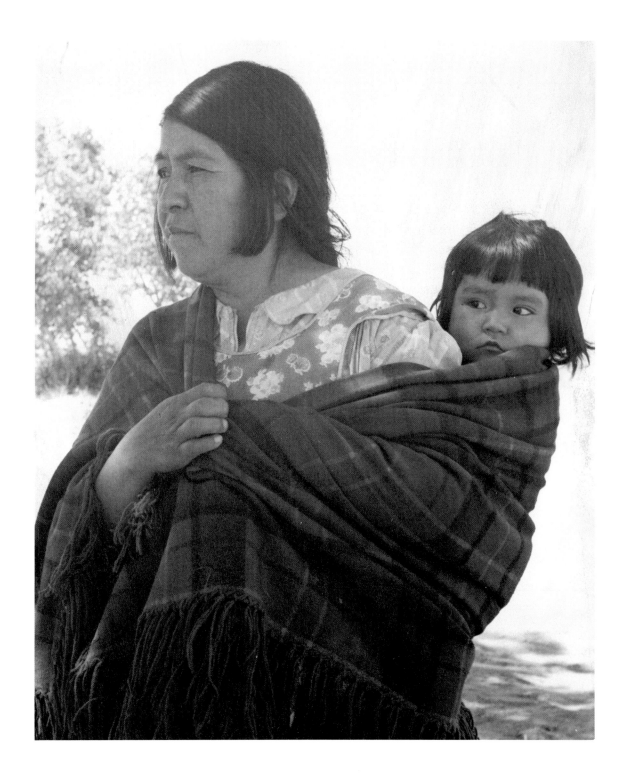

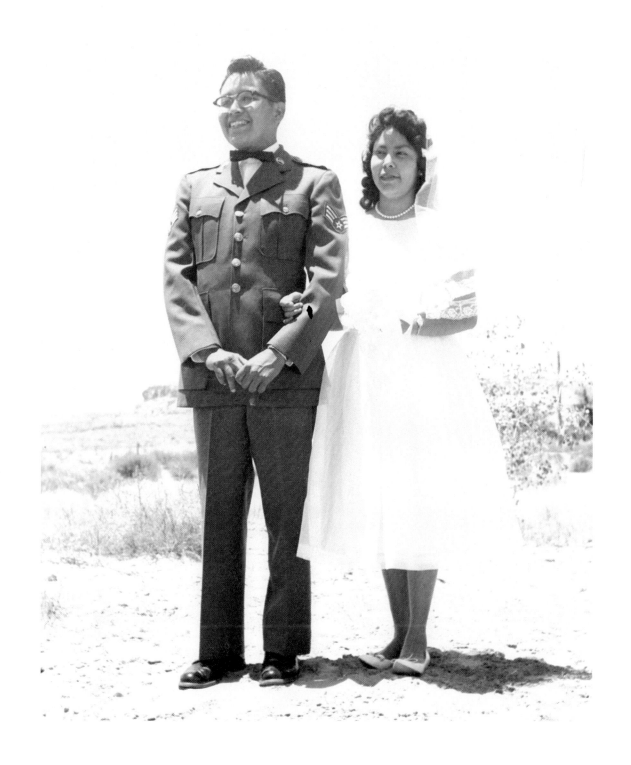

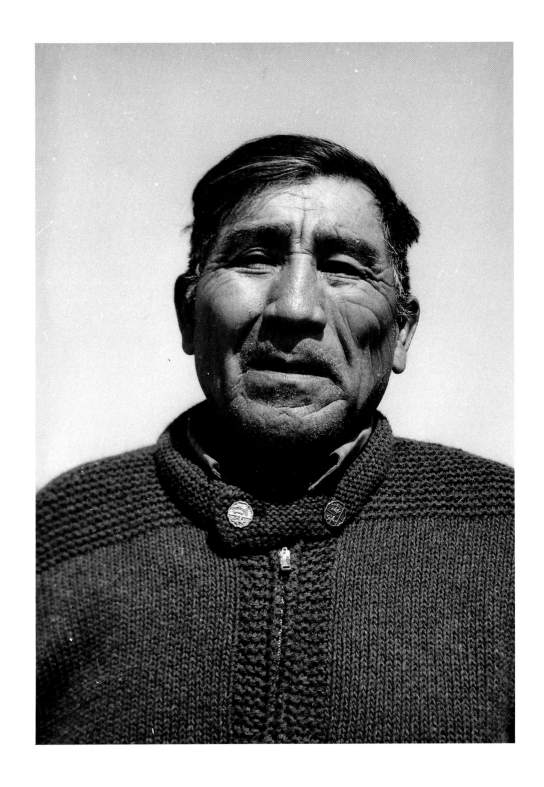

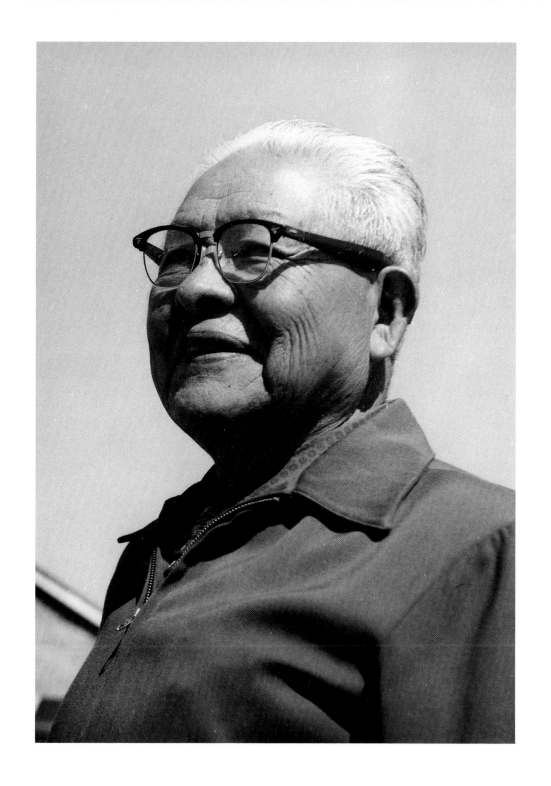

Owen Seumptewa

All photography is communicating . . . I like photographing people because you only have that one time with them, you can't go back. Two years later they're older, they may not want you to take their picture, they may no longer be alive . . . The older Hopis are the people I really like working with. Many people want their mothers or fathers photographed and will ask me to do it. Only once did I go up to some older people and ask them directly if I could take their picture; usually the children request that I do so.

One of my goals is to preserve a little bit of today for forty, fifty, or sixty years from now . . . I feel good about who the Hopi people are, their philosophies, their differences in opinion, the manner in which they view their life. It is a very strong, rich culture . . .

OWEN SEUMPTEWA was born in 1946 in Bellmont, Arizona outside Flagstaff. His parents took him home to the Hopi reservation almost every weekend when he was growing up. He attended schools in Flagstaff and graduated from Northern Arizona University in 1969 with a major in biology. He began taking photographs in high school and took a class in photography in college. He worked for the Northern Arizona Supplementary Education Center during college and was responsible for all the media needs of the center including video-taping, photography and darkroom work. In 1969, he became Assistant Director of the Learning Resources Center at Navajo Community College. He returned to the Hopi reservation in 1975 where he became Media Specialist and Assistant Director of the Hopi Health Professions Program. He taught photography at the Hopi Center of Northland Pioneer College between 1975 and 1982. In 1978, he became Director of Education for the Hopi Tribe. In 1982, he resigned to return to Northern Arizona University to complete graduate studies in education and health care.

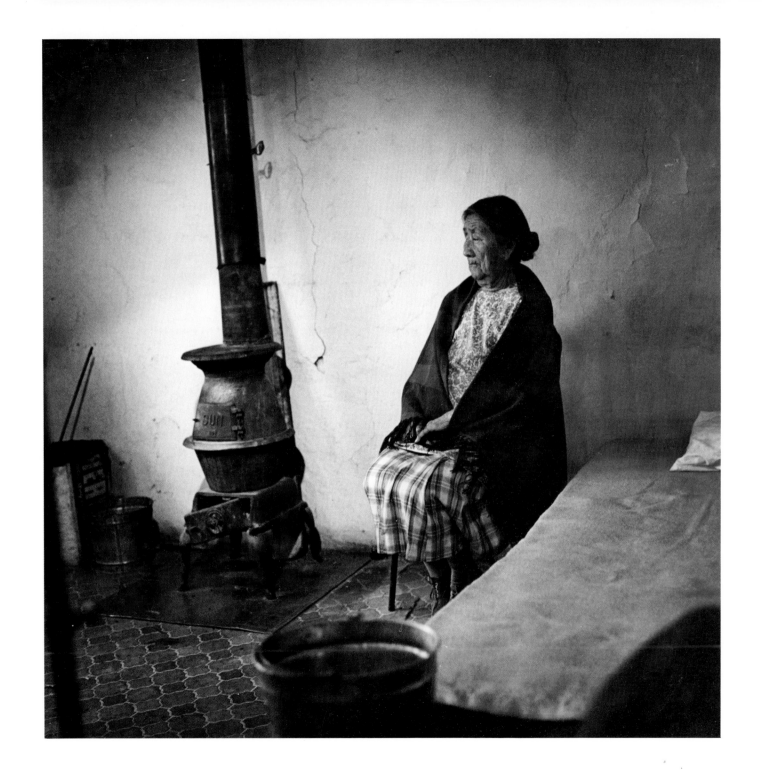

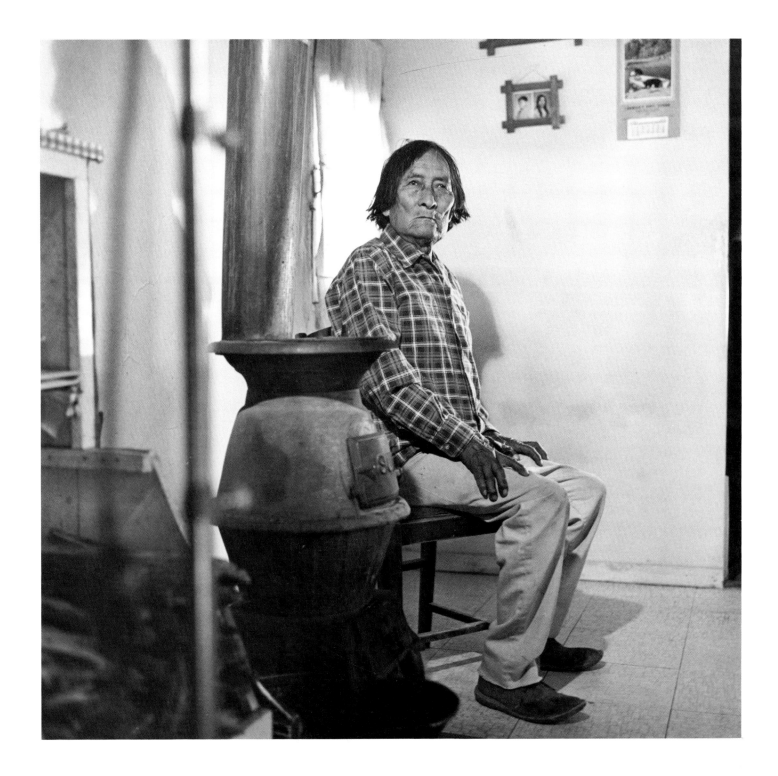

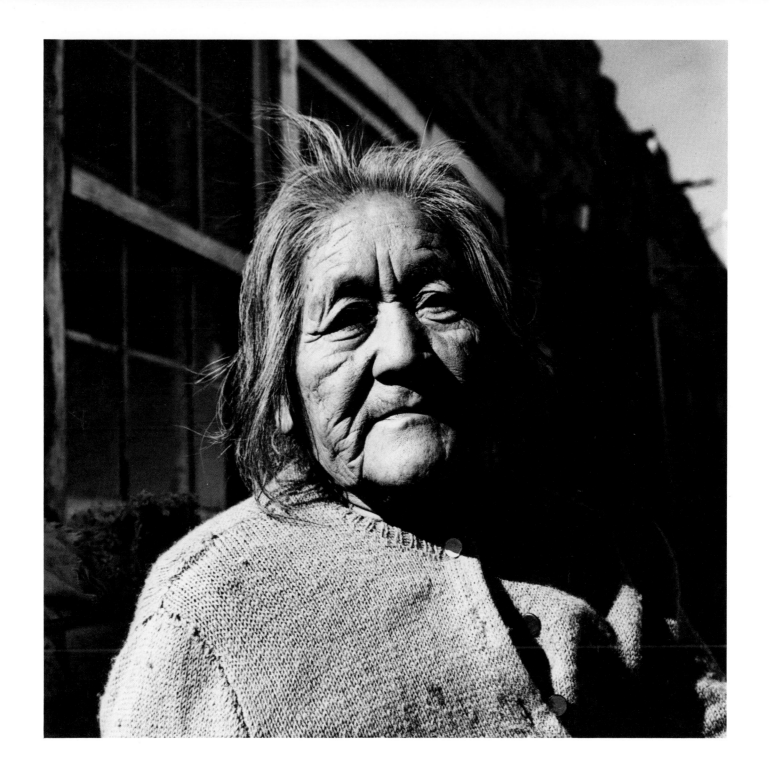

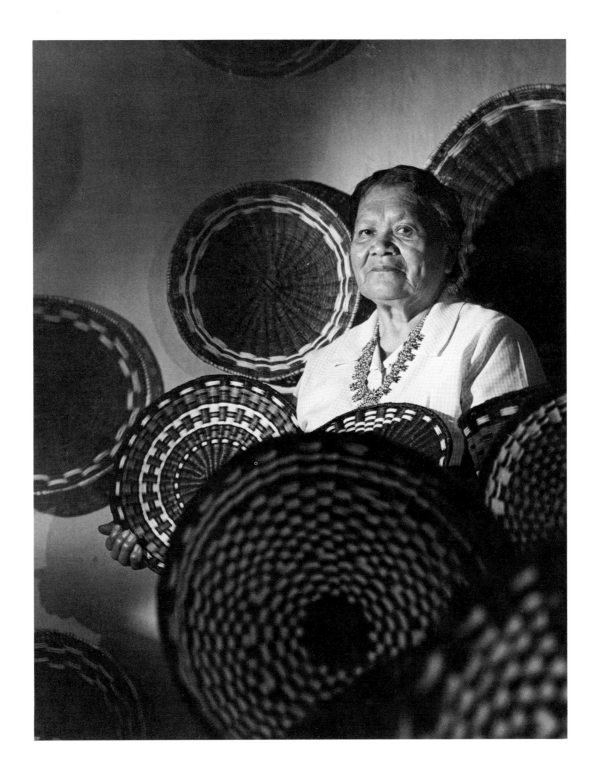

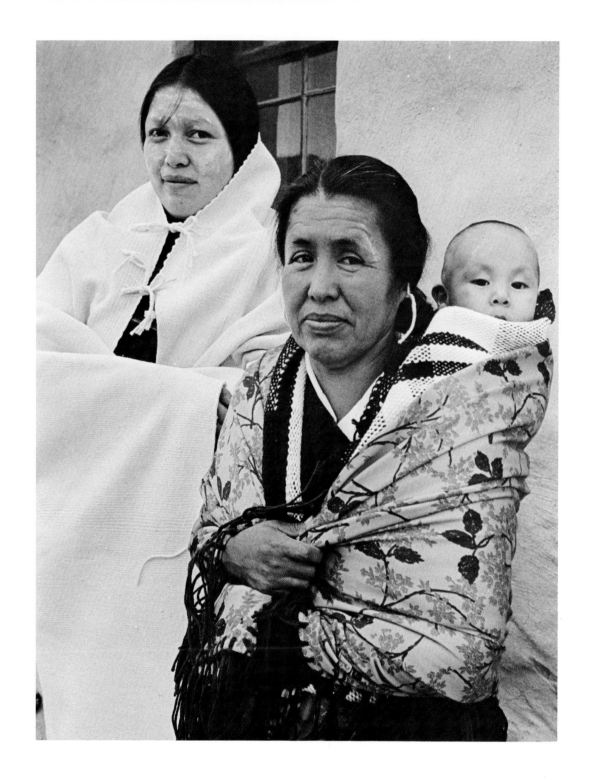

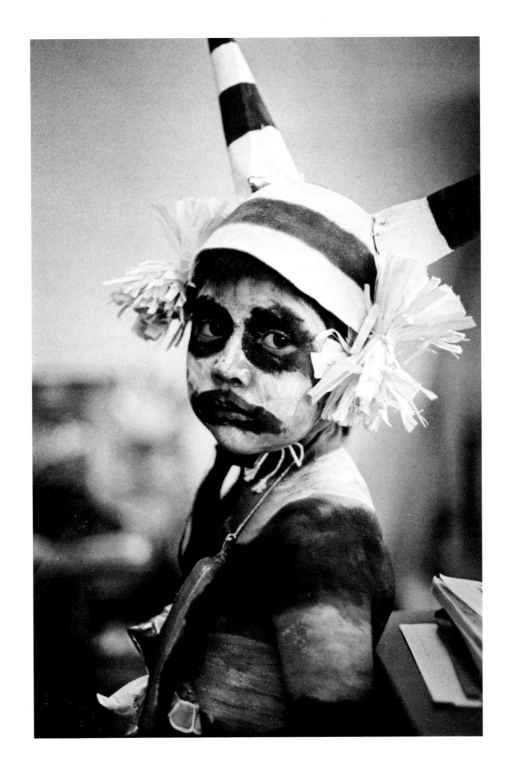

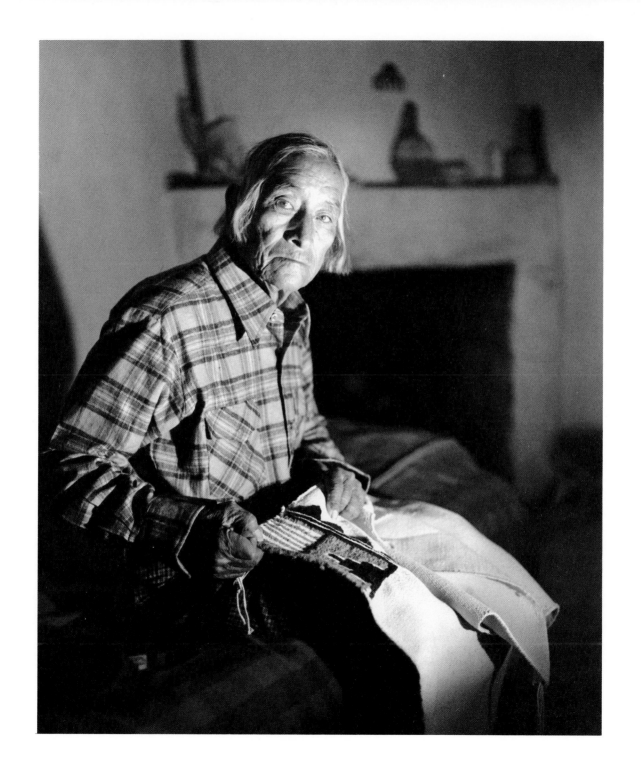

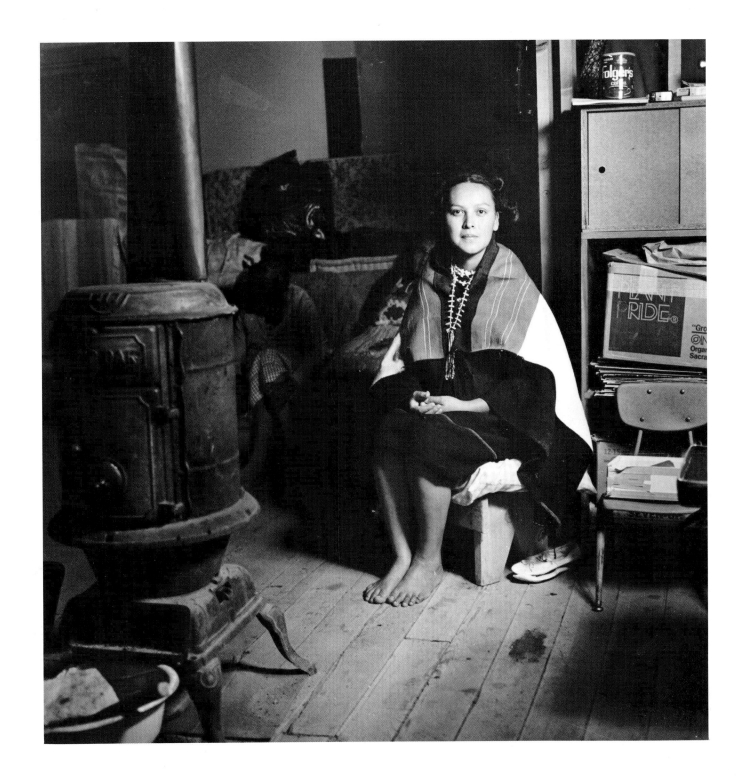

Freddie Honhongva

Most of my photography consists of per-sonal views of familiar surroundings.

FREDDIE HONHONGVA was born in Old Oraibi in 1955. He attended the Hopi Day School in Oraibi and later went to Sherman High School, the Indian boarding school in Riverside, California. He returned to Arizona and attended Mesa Community College between 1976 and 1978 and Arizona State University in 1979, choosing a major in art. He took his first class in photography from Owen Seumptewa at the Hopi Center of Northland Pioneer College. Between 1980 and 1982, he worked as a media technician and production assistant to Victor Masayesva, Jr. on an Ethnic Heritage Program grant awarded by the Department of Education.

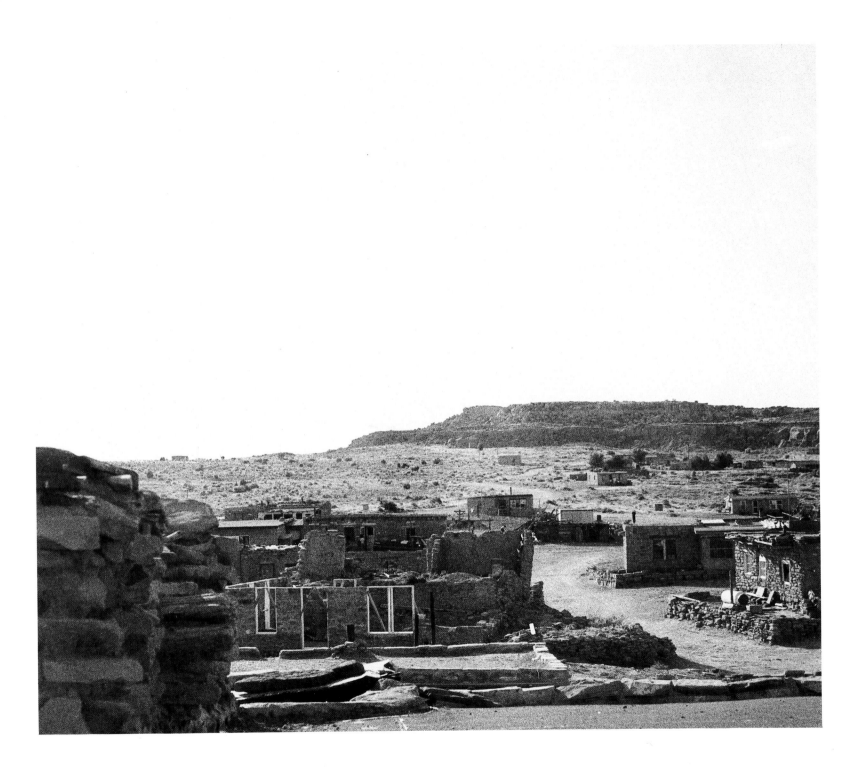

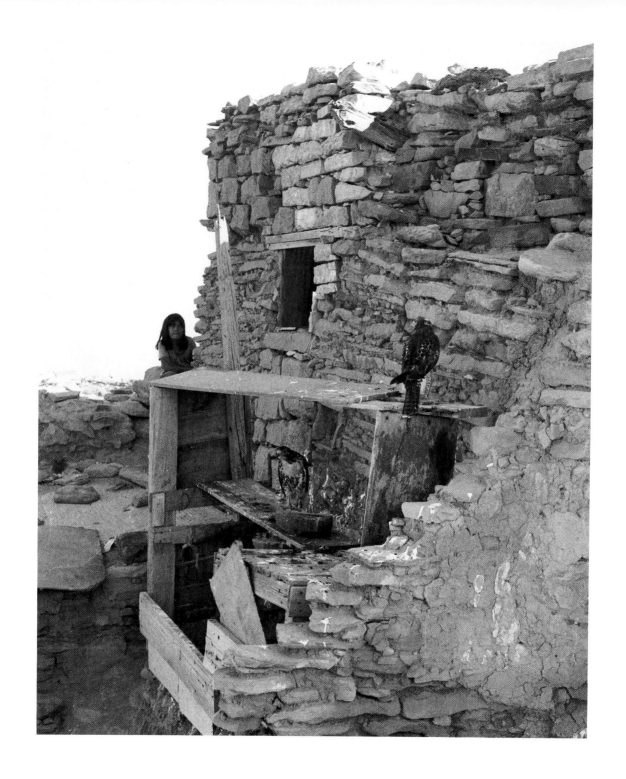

Merwin Kooyahoema

*It is difficult to imagine that I would ap-
proach photography in any other way than
as a means of creating some kind of beauty,
as a means of creating an art form: creating
beauty out of the land that has been the
Hopi way of life for centuries, creating
beauty out of the people who maintain their
own traditional ways, creating beauty out
of today's Hopi.*

MERWIN KOOYAHOEMA was born
in 1957 and grew up on Second
Mesa. He attended Second Mesa and
Oraibi day schools and went to high
school in Woodstock, Vermont. In
1976, he attended the University of
Arizona for one year where he studied
art. He returned to the reservation be-
fore going back to school and worked
as a photographer for the tribal news-
paper. In 1978, he went to the Institute
of American Indian Art in Santa Fe,
New Mexico, where he graduated in
1980 with an AFA degree in two-
dimensional art. He took a job as a
Health Education Aide for the Hopi
Tribe in 1981. He has continued to take
photographs although his primary
interest in art remained in painting
and drawing.

Fred Kootswatewa

*My primary goal is to establish and imple-
ment a full-services public relations de-
partment which will be geared toward
presenting the Hopi people in a way that is
acceptable to them: well-rounded, positive,
and non-exploitative. These are goals I also
consider in my own photography.*

FRED KOOTSWATEWA was born in
Winslow, Arizona, and grew up in
Tuba City, which borders the Hopi res-
ervation. He attended schools in Tuba
City and went to Phoenix College and
Northern Arizona University after
serving in Viet Nam. In 1977, he re-
turned to the reservation to work as
staff assistant to the Chairman of the
Hopi Tribe. In 1981 he became Public
Relations Specialist for the tribe and
assisted in the coordination of the
National Geographic article on the Hopi
published in November, 1982, and the
1982 book, *Hopi,* published by Abrams.
He has had several years' experience
as a newspaper reporter and photog-
rapher, working for *Qua Toqti* and the
Hopi Tribal News.

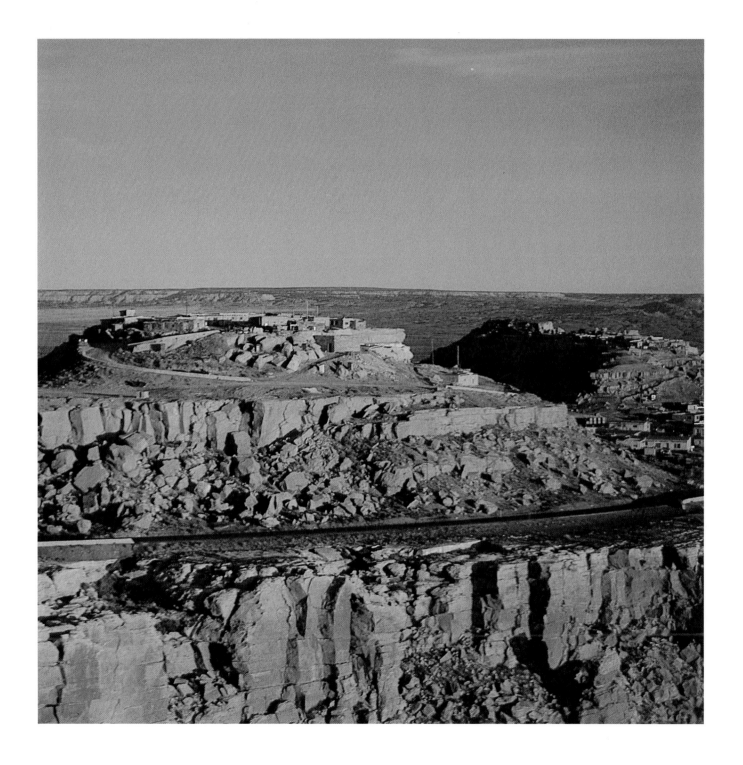

Georgia Masayesva

*Many of my photographs focus on archi-
tectural elements —structures found in or
near my home village of Kykotsmovi. Tex-
tures of rock walls, mud doorways, weath-
ered doors, and beams are often used as
background for portraits. Many of these
structures have been standing for many
years; some are still occupied; others re-
main empty after many generations.*

*Unoccupied structures with their de-
teriorating interiors and doors stand si-
lently, communicating only their strength
and endurance. They may contain evidence
of past occupants —a small hanging beam
that once held a weaving loom; an old
wooden box that was used to plug up a hole
in the window. These structures have a
unique character that cannot be replaced by
cinderblock houses or trailers.*

GEORGIA MASAYESVA was born in
Phoenix and grew up outside of
Flagstaff, Arizona. She spent her
summers on the reservation and
moved back there permanently after
graduating from high school in 1965.
She later attended college at the Uni-
versity of Arizona where she received
a B.A. in art in 1980. In 1981, she re-
ceived a master's degree in counseling,
then joined the faculty to teach art at
the Hotevilla-Bacavi Community
School on Third Mesa.

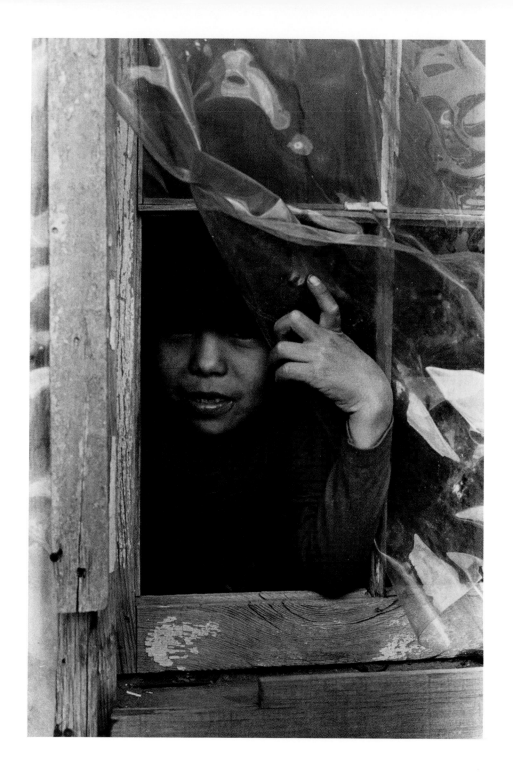

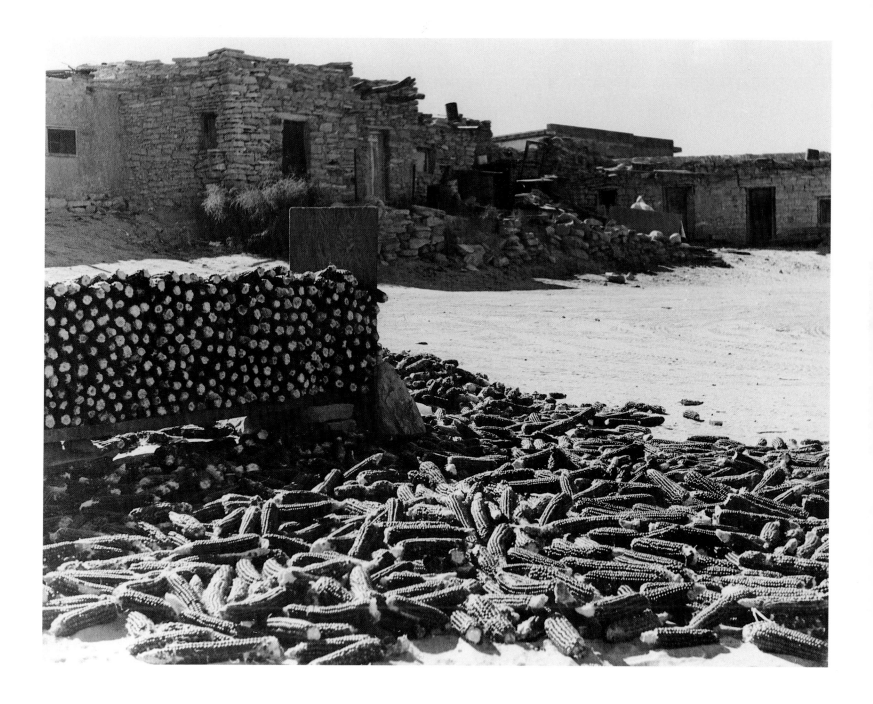

Victor Masayesva, Jr.

In a complex world of diverse cultural groups, we move in tandem but in complete ignorance of the other half of the world, in the way that life and death slip by one another.

Photography is a philosophical sketching that makes it possible to define and then to understand our ignorance. Photography reveals to me how it is that life and death can be so indissolubly one; it reveals the falseness of maintaining these opposites as separate. Photography is an affirmation of opposites; the negative contains the positive.

For me, photography is a way of imagining life's complexity. It provides an analogy for philosophical comprehension. It is something I do personally because it leads me to some satisfactory understanding of that complexity.

VICTOR MASAYESVA, JR., was raised in the Hopi village of Hotevilla on Third Mesa. He went to grade school on the reservation and attended the Horace Mann School in New York. While at Horace Mann, he received the Ion Theodore Fine Arts Award for Excellence in 1970. In 1976, he graduated from Princeton University where he had been selected University Scholar in 1973. He majored in literature and took his first course in photography from Emmet Gowin. In 1978, he attended the University of Arizona on a Ford Foundation Fellowship for graduate studies in English literature and photography. In 1980, he became director of the Ethnic Heritage Program at Hotevilla and supervised the production of a series of video-taped documentaries in the Hopi language. In 1982, he formed his own video-production company in Hotevilla and taught photography at the Hopi Center of Northland Pioneer College. During the summer of 1982, he was selected to attend the Ansel Adams Photographic Workshop in Carmel, California. His poetry and photography have been previously published in *Sun Tracks.*

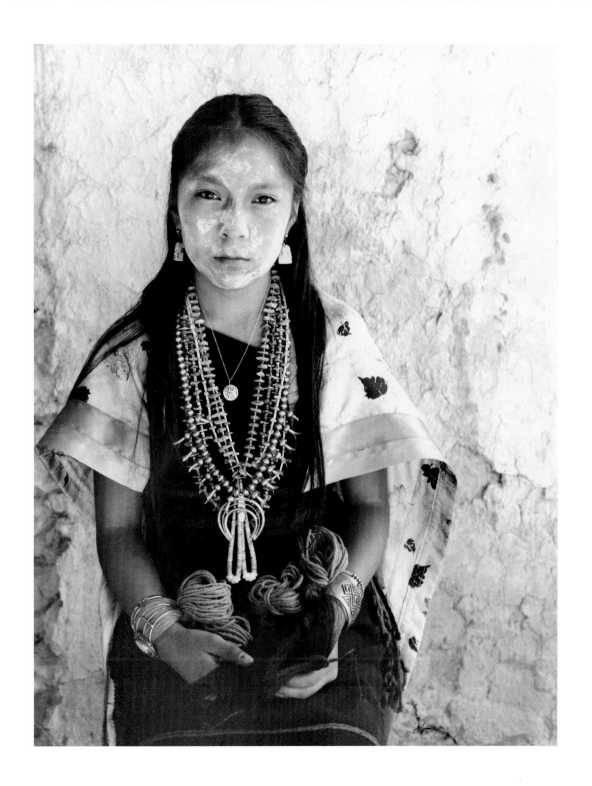

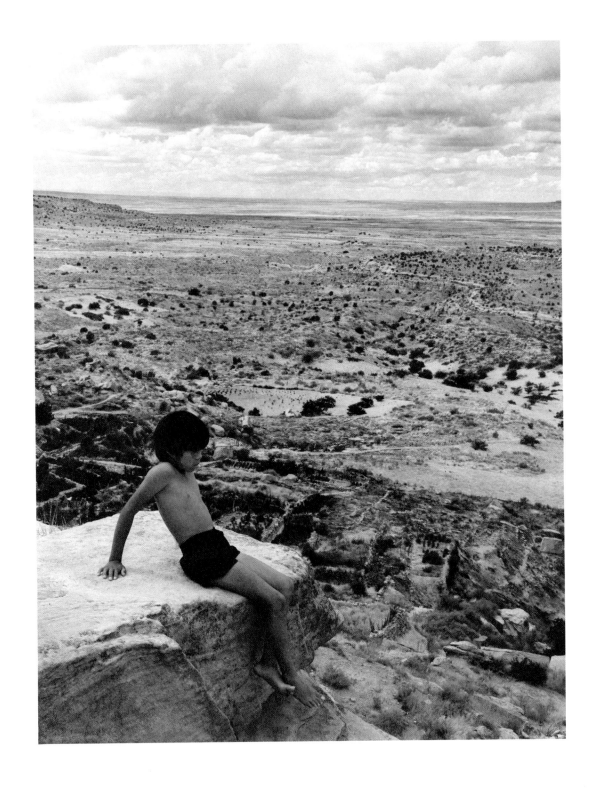

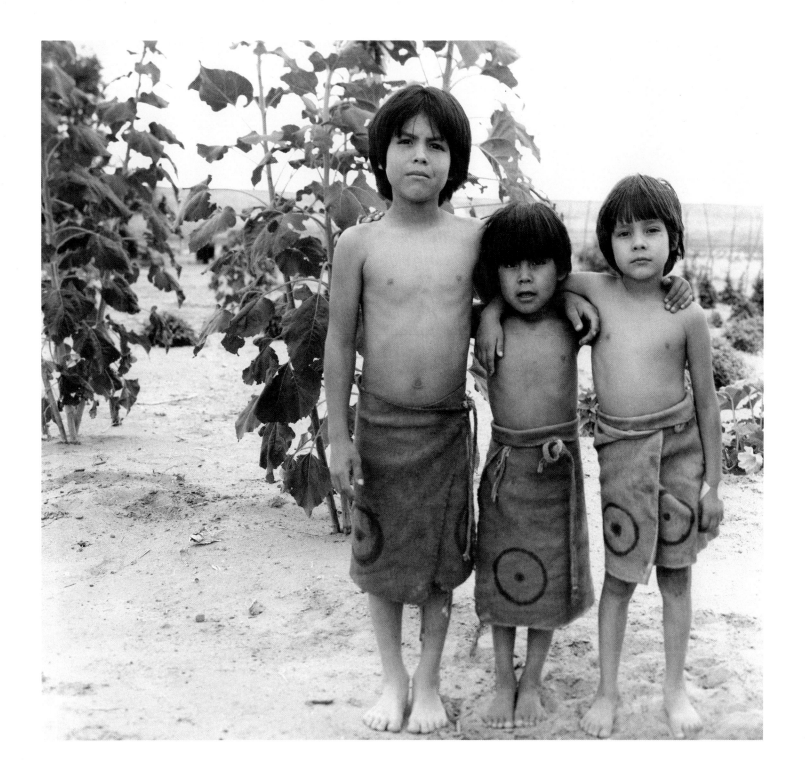

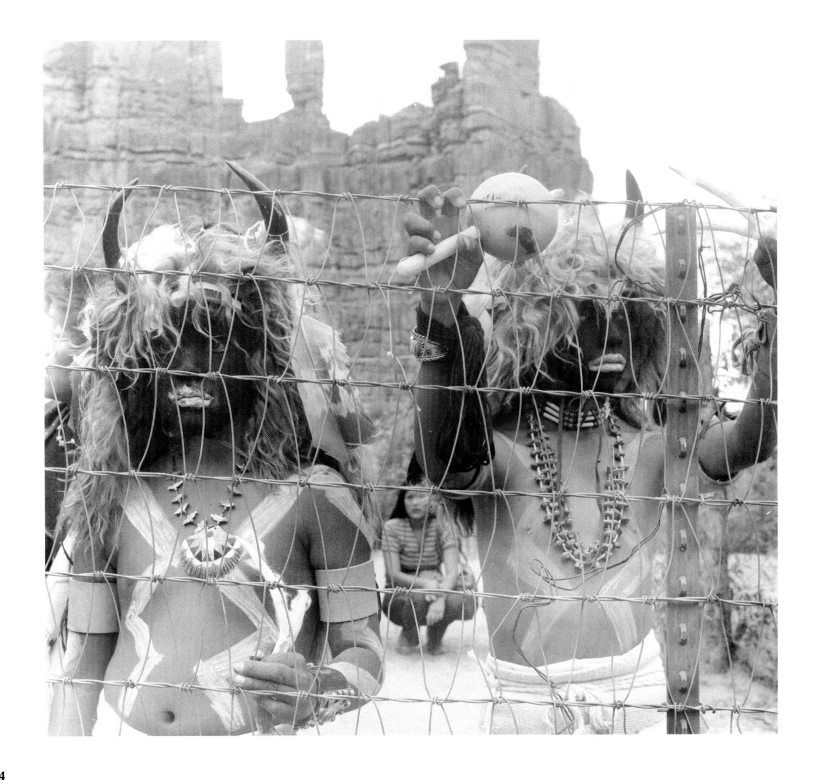

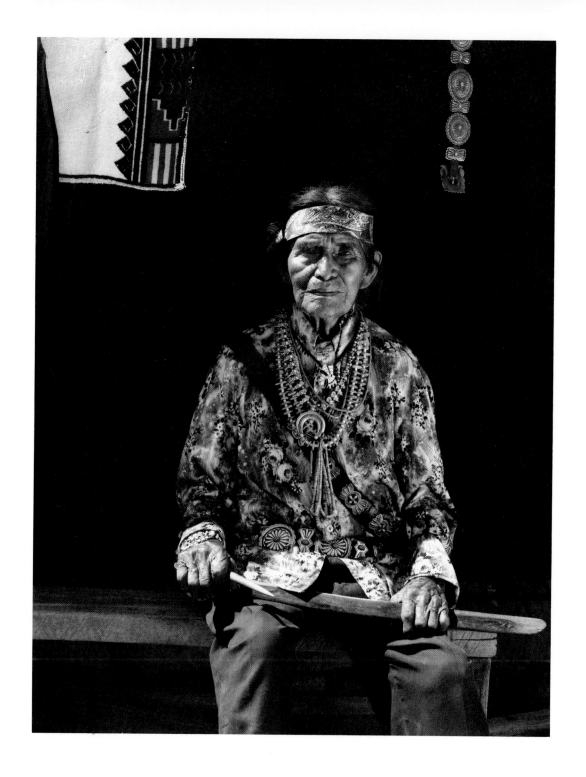

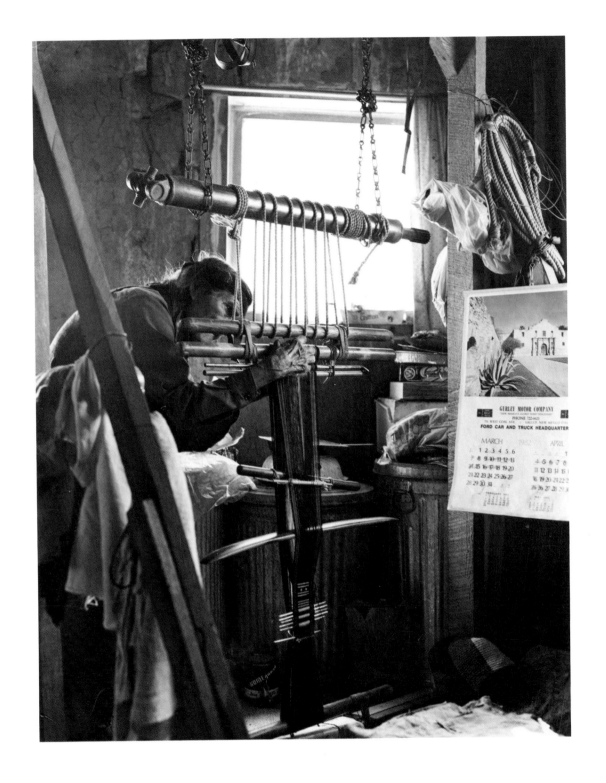

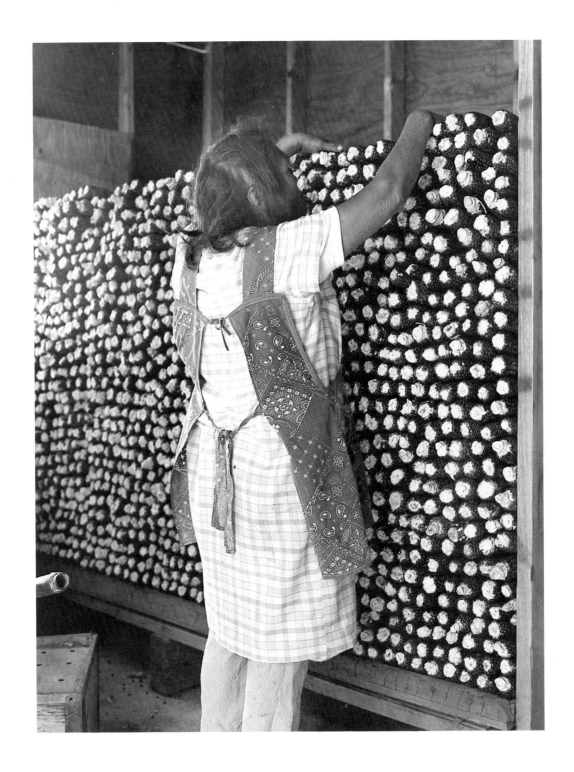

Planting

In the Powamu wars
In the obligation to the earth and the seed
In the work to be done now
In the rush to completion
In this struggle with the yielding earth
We lie sick, late into midnight,
In this Powamu time.

Always present
The someone's borning
And true too
That someone is dying
In this planting time.

Famine

Flies shelled and husked by the blowing sand
It was a windy year

We dug our cornplants out of the sand
And lived on watermelon seeds

There was a lot that we ate that year
In the winter-time we ate our children.

Prophecy

We waited for the rain all summer.
We saw the rain fall in standing rows
Far away from us
And wanted to know.

Too early the sun began to pull away from us.
The sand heat in the fields chilled
Before running the length of watermelon vines.

This morning there was a promise.
Clouds rising from *Nuvatukyaovi*
The Ancient Mask rising
Some say, speaking:
 Uyi matyawyak tusungtini.

Surviving

We've come through the winter again.
When doubt came tangling us in spiderwebs
Following the big freeze
We found causes
And deaths
When often there were none.

We found the *pawikim* not returning
(When it was too early)
And the flowers not burning beneath
(When it was too early)
And said:
 Something in the air
 Sombody ill
 Something wrong.

We've come through the winter again.
Our hearts lie deep
After the planting
And we wait, wait, wait.
We've come through the winter again.

Lightning

Lightning hit Sarah's house because she is a Christian.
Who told you that's why?

My friend.
You mean the priest's son?

Yes. He told me his father and some other guys went into Sarah's house and took something out of there.

Whirlwinds

"It can twist your heart out, that tuviphayang,
*that dust devil," my aunt said once when we were
carrying water.*

Now that aunt of yours has got a whirlwind
of a lover.

*Shortly thereafter, one whirlwind came into her
house in the afternoon. It came through the window
intact and veered around the corners before slamming
out through the screen door. All that time my aunt
held her breath, clamped her hands over her belly
and the top of her head.*

That aunt of yours has been taking everything:
the orchards, fields, saddles, blankets and bridles.
I don't know what for, she's only a woman.
That dust devil must have got into her and
twisted her senses.

*I have always wondered about that summer
afternoon; what she made of the dust devil going
through her house.*

They say your aunt has been mentioned by
the boy's father. The father accuses your aunt of
twisting the heart out of the boy so that he does
not want to live.

*My aunt lives in a house high on a hill where the
winds meet and disperse around the fine edges of her
sandstone house. I've not found it strange to meet a
dust devil there, on fine afternoons.*

Winter Storytelling

We fed our fire with ashes
And pretended it was warm
Saw the sun on his last decline
And prepared for winter nights.

They told one story

One winter when the snow shed May snakes
When the owls passed quietly through the snow
Crawling through the snow
Like a black ciphering snake
All in one row
The owls passing through the snow

One story about *tikuywuhti* — La Llorona
Running through the winter night
Hair flying, on fire.

They spoke of La Llorona:
The black and white of things
The shape of things to come.

They finished their story
Guided and guarded solely by night stars
Warmed solely by ash fires
While the owls wove patterns in the snow.

The *Kikmongwi's* Rain Song

The people turned against me. *Palolokong* was called.

> *The waters gathered and fled*
> *Joined and angled outwards and back*
> *All in random motion towards our home*
> *All those* palolokong *children to our home.*

We lived by rain. We are destroyed by rain, here, at *Tuwanasavi.*

> *The silence lies cradled*
> *Sleeping hours after the rain*
> *While the flurries of emotion*
> *All drained somewhere, drowned in fever*
> *We are left alone on high ground.*

Ihimi
Mine

i ihimi Everything *itam himlalwa*
And this *itam pu sumatak it* Land
Mine. *ahw oki,* now.

1. Joanna Cohan Scherer, *Indians: The Great Photographs that Reveal Native American Indian Life* (New York: Crown Publishers, Inc., 1974), p. 13.

2. John Wesley Powell, *First Annual Report of the Bureau of Ethnology* (Washington, D.C.: Government Printing Office, 1881), xi.

3. Keith Basso, "History of Ethnological Research," in *Handbook of North American Indians: Southwest,* vol. 9 (Washington, D.C.: Government Printing Office, 1979), p. 17.

4. Margaret B. Blackman, "Posing the American Indian," *Natural History Magazine,* vol. 89, no. 10 (1980), p. 70.

5. Donna A. Longo, "Photographing the Hopi," *Pacific Discovery Magazine,* vol. XXXIII, no. 3 (1980), p. 11.

6. Christopher M. Lyman, *The Vanishing Race and Other Illusions* (Washington, D.C.: Smithsonian, 1982), p. 17.

7. Frederick Monsen, "Pueblos of the Painted Desert," *Craftsman,* vol. XXII (April–September 1907), p. 33.

8. Ibid.

9. George Wharton James, *The Indians of the Painted Desert* (Boston: Little, Brown & Co., 1919) p. 62.

10. Joanna Cohan Scherer, "You Can't Believe Your Eyes: Inaccuracies in Photographs of North American Indians," *Studies in the Anthropology of Visual Communication,* vol. 2, no. 2 (Fall, 1975), p. 67.

11. James, *Indians,* p. 78.

12. Ibid., p. 77.

13. Ibid., p. 78.

14. Edward H. Spicer, *Cycles of Conquest* (Tucson: The University of Arizona Press, 1962), p. 201.

15. James, *Indians,* p. 78.

16. Ibid., p. 38.

17. Frederick Monsen, "The Destruction of Our Indians," *Craftsman,* vol. XI (October 1906–March 1907), p. 687.

18. James, *Indians,* p. 117.

19. George Wharton James, "The Snake Dance of the Hopis," *Camera Craft* vol. 6, no. 1 (November 1902), p. 7.

20. Longo, "Photographing the Hopi," p. 12.

21. Ibid.

22. Ibid.

23. "Cupid at Home in Hopiland," published in postcard form by Frashers Fotos, Pomona, California.

24. Jeff Burger, "Arizona Highways at a Crossroad," *Phoenix* (November, 1982), p. 67.

25. *Arizona Highways,* vol. 26, no. 7 (July 1950), p. 5.

26. *Arizona Highways,* vol. 47, no. 6 (June 1971), p. 1.

27. Jerry Jacka, *in* Pat Conner, "Jerry Jacka: Photographer for All Seasons," *The Ticket* (February 11, 1982), p. 11.

28. John Running, "Hopi Notes," *Plateau,* vol. 51, no. 3 (Flagstaff, 1979).

29. Owen Seumptewa, personal communication.

30. Fred Kootswatewa, personal communication.

31. Owen Seumptewa, personal communication.

32. Fred Kootswatewa, personal communication.

33. Victor Masayesva, personal communication.

34. Bruce Baird, "Reflections—Native Americans in Media" *in* Elizabeth Weatherford, ed. *Native Americans on Film and Video* (New York: Museum of the American Indian/Heye Foundation, 1981).

35. Owen Seumptewa, personal communication.

36. Owen Seumptewa, personal communication.

Arizona Highways, vol. 26, no. 7 (July 1950): 5.

———vol. 47, no. 6 (June 1971): 1.

Basso, Keith. "History of Ethnological Research," in *Handbook of North American Indians: Southwest.* vol. 9, Washington, D.C.: Government Printing Office, 1979, pp. 14–21.

Blackman, Margaret B. "Posing the American Indian," *Natural History,* vol. 89, no. 10 (1980): 68–74.

Burger, Jeff, "Arizona Highways at a Crossroads," *Phoenix,* (November 1982): 67–71.

Conner, Pat. "Jerry Jacka: Photographer for All Seasons," *The Ticket* (Phoenix: February 11, 1982): 11.

James, George Wharton. "The Snake Dance of the Hopis," *Camera Craft,* vol. 6, no. 1 (November 1902):3 –10.

———. *The Indians of the Painted Desert.* Boston: Little, Brown & Company, 1919 (c. 1903).

Longo, Donna A. "Photographing the Hopi," *Pacific Discovery Magazine,* vol. 33, no. 3 (1980): 11–19.

Lyman, Christopher M. *The Vanishing Race and Other Illusions (Photographs of Indians by Edward S. Curtis).* Washington, D.C.: The Smithsonian Institution Press, 1982.

Monsen, Frederick. "Pueblos of the Painted Desert: How the Hopi Build their Community Dwellings on the Cliffs," *Craftsman,* vol. XII (April–September 1907): 16–33.

———"The destruction of our Indians: what civilization is doing to extinguish an ancient and highly intelligent race by taking away its arts, industries and religion," *Craftsman,* vol. XI (October 1906–March 1907): 683–691.

Powell, John Wesley. *First Annual Report of the Bureau of Ethnology.* Washington, D.C.: Government Printing Office, 1881.

Running, John. "Hopi Notes," *Plateau,* vol. 51, no. 3 (Flagstaff, 1979).

Scherer, Joanna Cohan. *Indians: The Great Photographs that Reveal North American Indian Life, 1847–1929, From the Unique Collection of the Smithsonian Institution.* New York: Crown Publishers, 1974.

———"Introduction: Pictures as Documents (Resources for the Study of North American Ethnohistory)," *Studies in the Anthropology of Visual Communication,* vol. 2, no. 2 (Fall 1975): 65–66.

———"You Can't Believe Your Eyes: Inaccuracies in Photographs of North American Indians," *Studies in the Anthropology of Visual Communication,* vol. 2, no. 2 (Fall 1975): 67–79.

Spicer, Edward H. *Cycles of Conquest.* Tucson: The University of Arizona Press, 1962.

Weatherford, Elizabeth, ed. *Native Americans on Film and Video.* New York: Museum of the American Indian/Heye Foundation, 1981.